Cool Restaurants San Francisco

teNeues

Imprint

Editors:	Martin Nicholas Kunz, Katharina Feuer
Photos (location):	Ulrich Schonart (Ana Mandara), Craig Stoll (Delfina, food) All other photos by Martin Nicholas Kunz and Katharina Feuer
Introduction:	Katharina Feuer
Layout & Pre-press: Imaging: Map:	Martin Nicholas Kunz, Susanne Olbrich Susanne Olbrich go4media. – Verlagsbüro, Stuttgart
Translations:	SAW Communications, Dr. Sabine A. Werner, Mainz Céline Verschelde (French), Silvia Gomez de Antonio (Spanish), Elena Nobilini (Italian), Nina Hausberg (German / recipes)

Special thanks to Nicole Kidd and Mitzi S. Palmer for their
expert advise, Andalu, Aziza, La Folie and MECCA for their support.
Produced by fusion publishing GmbH, Stuttgart . Los Angeles
www.fusion-publishing.com

Published by teNeues Publishing Group

teNeues Publishing Company
16 West 22nd Street, New York, NY 10010, USA
Tel.: 001-212-627-9090, Fax: 001-212-627-9511

teNeues Book Division
Kaistraße 18, 40221 Düsseldorf, Germany
Tel.: 0049-(0)211-994597-0, Fax: 0049-(0)211-994597-40

teNeues Publishing UK Ltd.
P.O. Box 402, West Byfleet, KT14 7ZF, Great Britain
Tel.: 0044-1932-403509, Fax: 0044-1932-403514

teNeues France S.A.R.L.
4, rue de Valence, 75005 Paris, France
Tel.: 0033-1-55 76 62 05, Fax: 0033-1-55 76 64 19

teNeues Iberica S.L.
Pso. Juan de la Encina 2–48, Urb. Club de Campo
28700 S.S.R.R. Madrid, Spain
Tel./Fax: 0034-91-65 95 876

www.teneues.com

ISBN-10:	3-8327-9067-5
ISBN-13:	978-3-8327-9067-7

© 2005 teNeues Verlag GmbH + Co. KG, Kempen

Printed in Italy

Bibliographic information published by
Die Deutsche Bibliothek. Die Deutsche Bibliothek lists
this publication in the Deutsche Nationalbibliografie;
detailed bibliographic data is available in the Internet
at http://dnb.ddb.de.

Contents	Page

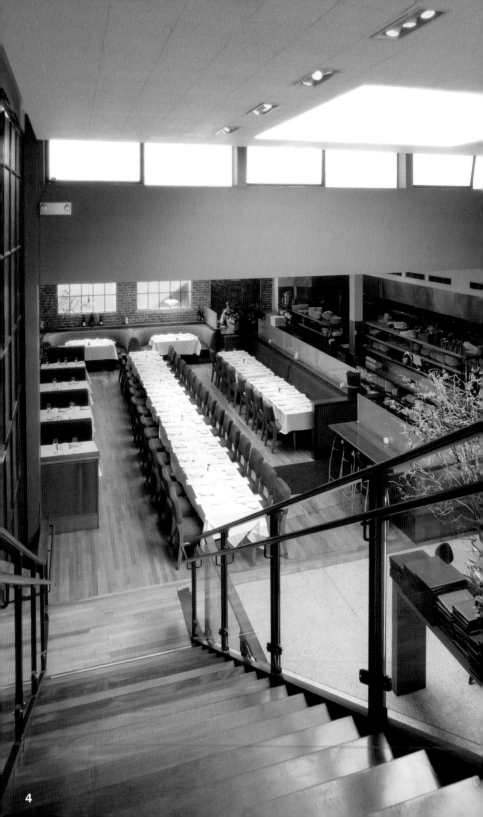

Introduction

San Francisco is a model for cultural diversity. Thousands of kilometers away from their country of origin, "natives" from all over the world cultivate their traditions and customs in homes that are barely a few kilometers square—and they live in harmony with their neighbors. Here, a fascinating topography and a pictoresque city-scape converge as in no other city. The journey between Financial and Mission District, South of Market, the Italian district of North Beach or even the newly buzzing "hippie" quarter of Haigh Ashbury only stretches from one hillside to the next. European and Asian lifestyles join together as in no other place on American soil. Here, the world converges in a global village and exotic aromas percolate among the city's avenues. Authentic recipes from traditional cuisines are practised to perfection and you can enjoy an original Chinese dish, for once, without the irritating aftertaste of glutomate. Above all, though, it's the creative chefs who invent totally new menus from the diversity of all different kinds of tastes. That earns the city the best gourmet ratings. San Francisco discovered healthy eating alongside the coffee culture a lot earlier than most other American cities and it coined the phrase "Californian cuisine".

From amongst the range of these unique aspects, Cool Restaurants San Francisco introduces the most popular and attractive venues. This includes, for instance, the Slanted Door with a view across Bay Bridge or the vegetarian Greens Restaurant with a view over Golden Gate Bridge. At the Farallon, an ambience was created in the style of an underwater landscape, guests at the Foreign Cinema can watch cult films whilst dining, in the Bix there is live jazz in art-dèco surroundings, Mecca or Aziza are perfect locations for romantic dinners, the 2223 Restaurant, Absinthe, La Folie, Fifth Floor, Bacar, Gary Danko, Tartare or Town Hall provide the appropriate setting for business dinners and at Andalu each dinner guest enjoys a sumptuous meal at a fair price, before working off the calories at the AsiaSF.

Katharina Feuer

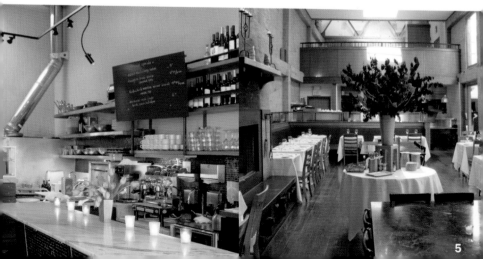

Einleitung

San Francisco ist das Musterbeispiel für kulturelle Vielfalt. Tausende von Kilometern von der Heimat entfernt pflegen die „Einheimischen" aus aller Welt ihre Traditionen und Eigenheiten und leben dabei auf wenigen Quadratkilometern in nachbarlicher Harmonie. Wie in keiner anderen Stadt treffen hier eine faszinierende Topographie und ein pittoreskes Stadtbild aufeinander. Die Reise zwischen Financial und Mission District, South of Market, dem italienischen Viertel North Beach oder etwa dem wieder quirligen Hippie-Viertel Haigh Ashbury geht jeweils nur von einem Hügel zum anderen. Europäisches und asiatisches Lebensgefühl treffen wie sonst nirgendwo auf amerikanischem Boden zusammen. Hier verschmilzt die Welt zum globalen Dorf, mischen sich exotische Gerüche zwischen den Straßenzügen. Authentische Rezepte der traditionellen Küchen werden zur Perfektion kultiviert, und man findet original Chinesisches einmal ohne geschmacksirritierendes Glutamat. Vor allem sind es aber die kreativen Küchenchefs, die aus der Vielfalt aller Geschmacksrichtungen ganz neuartige Menüs erfinden und der Stadt damit beste Feinschmeckernoten verleihen. Früher als die meisten anderen amerikanischen Städte hat San Francisco neben der Kaffeekultur auch gesundes Essen entdeckt und den Begriff der „kalifornischen Küche" geprägt.

Aus der Melange dieser Besonderheiten präsentiert Cool Restaurants San Francisco die beliebtesten und attraktivsten Lokale. Dazu zählen beispielsweise das Slanted Door mit Blick auf die Bay Bridge oder das vegetarische Greens Restaurant mit Blick auf die Golden Gate Bridge. Einer Unterwasserlandschaft nachempfunden ist das Ambiente des Farallon, im Foreign Cinema kann sich der Gast während des Dinners Kultfilme ansehen, im Bix gibt es Life-Jazz in Art-Déco-Umgebung, Mecca oder Aziza sind perfekte Orte für romantische Dinner, das 2223 Restaurant, Absinthe, La Folie, Fifth Floor, Bacar, Gary Danko, Tartare oder Town Hall bieten den richtigen Rahmen für Geschäftsessen und im Andalu bekommt man schließlich ein üppiges Mahl zu einem fairen Preis, bevor man sich zum Austoben ins AsiaSF begibt.

Katharina Feuer

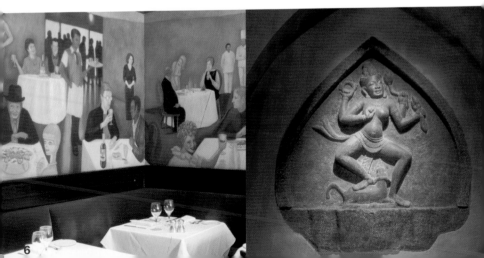

Introduction

San Francisco est l'exemple typique de la diversité culturelle. A des milliers de kilomètres de leur patrie, les « autochotones » du monde entier entretiennent leurs traditions et leurs particularités, tout en vivant en parfaite harmonie sur quelques kilomètres carré. On constate ici la rencontre exceptionnelle d'une topographie fascinante et d'une image pittoresque de la ville. Le circuit entre Financial et Mission District, South of Market, le quartier italien North Beach ou encore le quartier hippie Haigh Ashbury, redevenu trépidant, se fait uniquement d'une colline à l'autre. Les styles de vie européen et asiatique s'unissent ici de manière unique sur le sol américain. A San Francisco, le monde fusionne pour créer un village global, les odeurs exotiques se mélangent dans les rues. Les recettes authentiques des cuisines traditionnelles sont cultivées à la perfection et on peut déguster des plats chinois d'origine sans ce glutamate si irritant au goût. Mais ce sont avant tout les chefs cuisiniers créatifs qui inventent des menus nouveaux à partir de la diversité des goûts, offrant ainsi à la ville les meilleures notes données par les gourmets. Précédant la plupart des autres villes américaines, San Francisco a également, parallèlement à la culture du café, découvert la cuisine saine et marqué le terme de « cuisine californienne ».

S'appuyant sur le mélange de ces particularités, Cool Restaurants San Francisco présente les lieux les plus appréciés et les plus attrayants. En font partie par exemple le Slanted Door avec vue sur le Bay Bridge ou le Greens Restaurant végétarien avec vue sur le Golden Gate Bridge. L'ambiance du Farallon est inspirée d'un paysage sous-marin, le visiteur peut regarder des films cultes pendant son dîner au Foreign Cinema, on peut écouter au Bix des concerts de jazz dans un environnement Art Déco, Mecca ou Aziza sont des lieux parfaits pour un dîner romantique, 2223 Restaurant, Absinthe, La Folie, Fifth Floor, Bacar, Gary Danko, Tartare ou Town Hall constituent un cadre idéal pour les repas d'affaires et au Andalu, on obtient un repas consistant à un prix raisonnable, avant de se rendre au AsiaSF pour se défouler.

Katharina Feuer

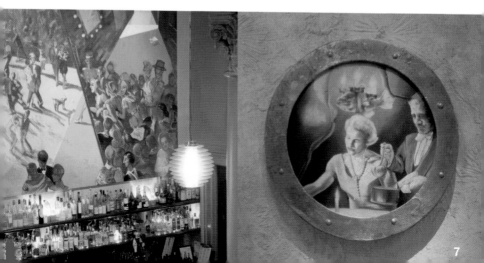

Introducción

San Francisco es un modelo ejemplar de la multiculturalidad. Los "nativos", procedentes de todo el mundo, cultivan sus tradiciones y singularidades a miles kilómetros de distancia de su patria y cohabitan en armonía vecinal en pocos kilómetros cuadrados. En esta ciudad se unen, como en ninguna otra, una topografía fascinante con un aspecto urbano pintoresco. El viaje entre Financial y Mission District, South of Market, el barrio italiano North Beach y el renacido barrio hippie Haigh Ashbury, transcurre de colina en colina. Los estilos de vida europeo y asiático conviven aquí como en ningún otro lugar en Estados Unidos. En esta ciudad el mundo se convierte en una aldea global y los aromas exóticos se mezclan en las calles. Las auténticas recetas de las cocinas tradicionales se cultivan hasta alcanzar la perfección. Aquí es posible encontrar la auténtica comida china sin el molesto glutamato. Pero son los cocineros los que, con su creatividad, inventan innovadores menús a partir de la amplia diversidad de estilos culinarios y sitúan a la ciudad entre los centros gastronómicos más importantes. San Francisco fue una de las primeras ciudades estadounidenses en descubrir la cultura del café y la comida sana, acuñando el término de "cocina californiana".

Cool Restaurants San Francisco presenta los locales más populares e interesantes de toda esta mezcla de singularidades. Ente ellos se encuentran, por ejemplo, el Slanted Door, con vistas al Bay Bridge, o el restaurante vegetariano Greens Restaurant, con vistas al Golden Gate Bridge. El Farallon, cuyo interior imita un paisaje submarino, o el Foreign Cinema, donde los clientes pueden ver películas de culto mientras disfrutan de la comida. En el Bix, decorado en estilo Art Déco, hay actuaciones de jazz en directo, el Mecca o el Aziza son lugares perfectos para las cenas románticas, y el 2223 Restaurant, el Absinthe, La Folie, el Fifth Floor, el Bacar, el Gary Danko, el Tartare y el Town Hall ofrecen el entorno perfecto para las comidas de negocios mientras que, en el Andalu, es posible disfrutar de una copiosa comida a un precio moderado antes de irse a bailar al AsiaSF.

<div align="right">Katharina Feuer</div>

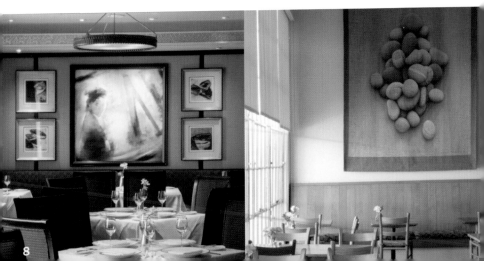

Introduzione

San Francisco è l'esempio tipico di varietà culturale. A migliaia di chilometri dalla loro patria, i "nativi" provenienti da tutto il mondo conservano le loro tradizioni e peculiarità in un'armoniosa convivenza su uno spazio di pochi chilometri quadrati. San Francisco, come nessun'altra città, riunisce in sé una topografia affascinante e un volto pittoresco. I vari tratti tra Financial e Mission District, South of Market, il quartiere italiano North Beach o l'animato quartiere hippy Haigh Ashbury si estendono solo da una collina all'altra. L'incontro fra il sentimento europeo ed asiatico per la vita non trova uguali in nessun'altra parte del territorio americano. Qui il mondo si fonde in un paese globale, da una strada all'altra si mescolano odori esotici. Le ricette autentiche delle cucine tradizionali vengono migliorate fino alla perfezione. Qui si ritrova la cucina cinese originale una volta tanto senza glutammato che stravolga i sapori. Ma sono soprattutto i creativi chef di cucina che, a partire dalla molteplicità di tendenze di gusto, inventano menu nuovi e conferiscono così a San Francisco un'eccellente nota di città per raffinati buongustai. San Francisco è stata una delle prime città americane a scoprire oltre alla cultura del caffè anche quella del mangiar sano, influenzando profondamente il concetto di "cucina californiana".

Cool Restaurants San Francisco attinge a questa mescolanza di peculiarità e presenta i locali più amati e più invitanti. Fanno parte di questa selezione, ad esempio, lo Slanted Door, con vista sul Bay Bridge, o il ristorante vegetariano Greens, con vista sul Golden Gate Bridge. L'ambiente del Farallon si rifà ad un paesaggio sottomarino, al Foreign Cinema il cliente può cenare guardando film cult, il Bix offre musica jazz dal vivo in un ambiente art déco, Mecca o Aziza sono posti perfetti per cene romantiche, il 2223 Restaurant, Absinthe, La Folie, Fifth Floor, Bacar, Gary Danko, Tartare o Town Hall offrono la cornice ideale per pranzi o cene d'affari. All'Andalu, infine, si può fare un pasto abbondante ad un prezzo equo prima di scatenarsi all'AsiaSF.

<div align="right">Katharina Feuer</div>

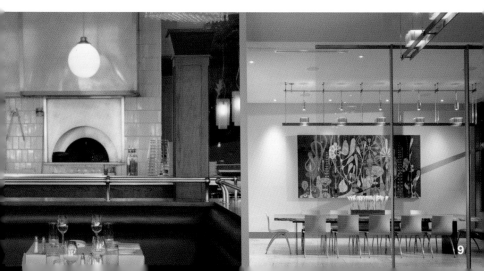

2223 Restaurant

Design: The Owners
Chefs & Owners: Melinda Randolph, David Gray

2223 Market Street | San Francisco, CA 94114 | Castro
Phone: +1 415 431 0692
www.2223restaurant.com
Opening hours: Sun–Thu 5 pm to 10 pm, Fri–Sat 5 pm to 11 pm,
Sun 10:30 am to 2:30 pm
Average price: $ 22
Cuisine: American, Californian
Special features: Private parties and special events

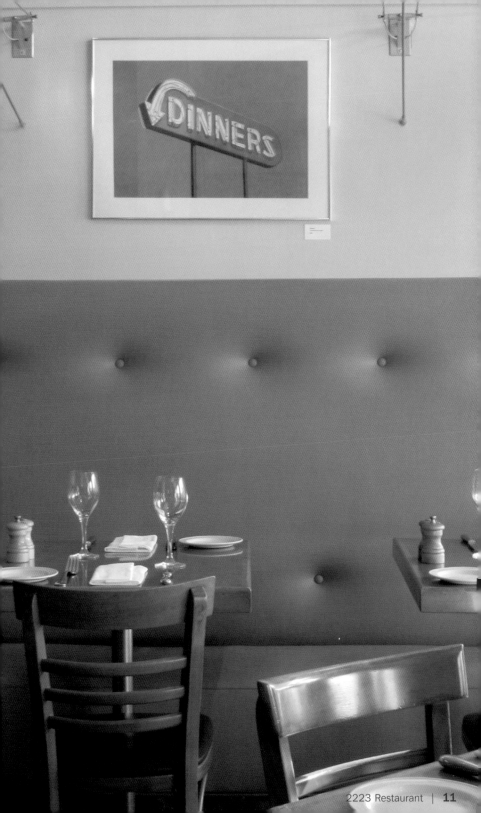

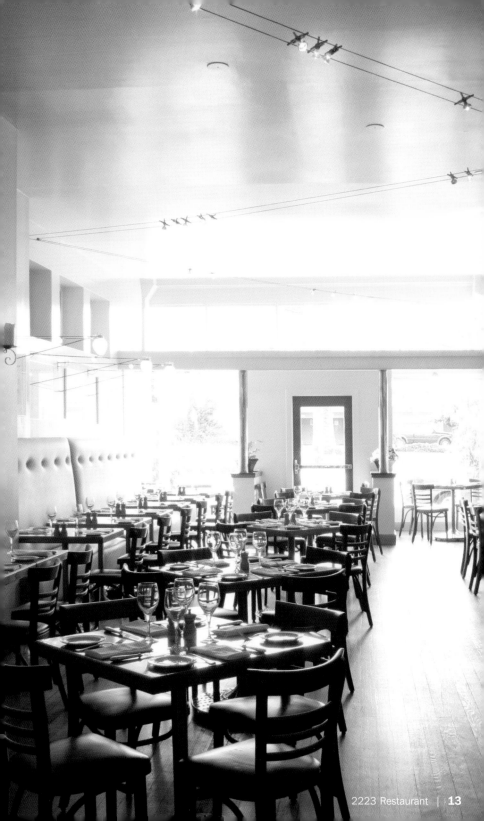

Absinthe Brasserie & Bar

Design: Disston Interior Design | Chef: Ross Browne
Owner: Bill Russell-Shapiro

398 Hayes Street | San Francisco, CA 94102 | Hayes Valley
Phone: +1 415 551 1590
www.absinthe.com
Opening hours: Lunch Tue–Fri 11:30 am to 2:30 pm, dinner Tue–Sat 5 pm to
11 pm, Sun 5 pm to 10:30 pm, brunch Sat–Sun 11 am to 3 pm
Average price: $ 23
Cuisine: French, Californian
Special features: Late night post-performance dinner

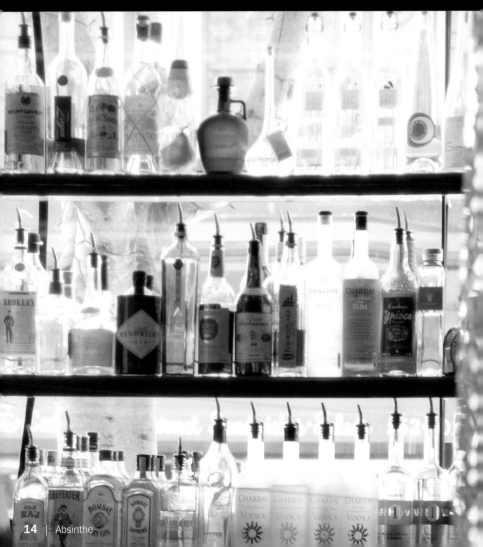

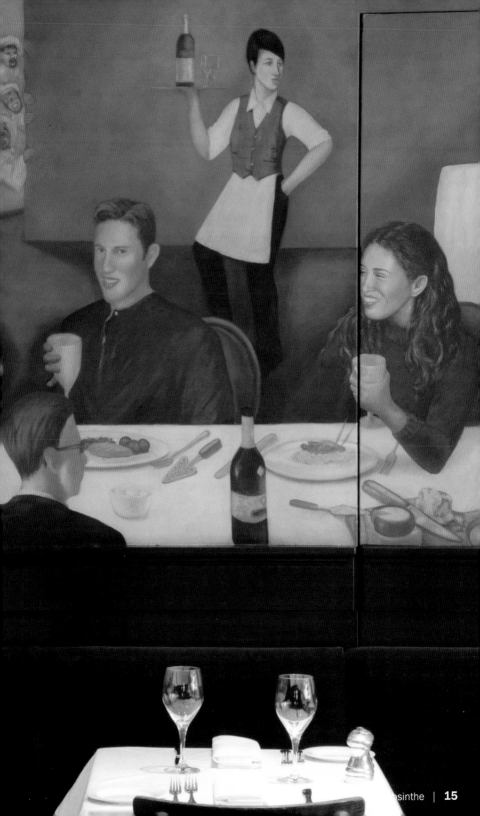

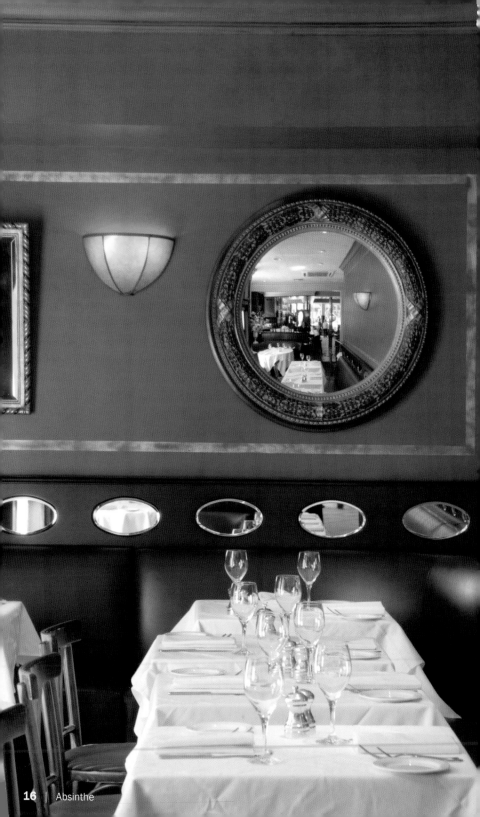

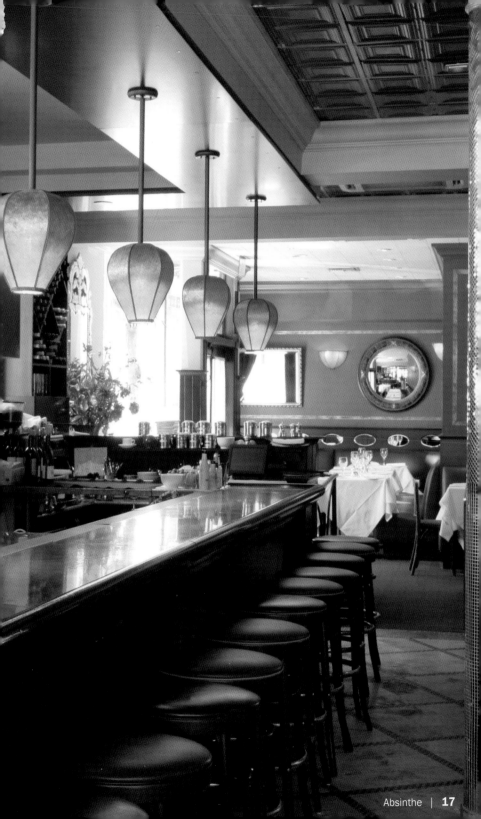

Ana Mandara

Design: Aline Ho, Peter McGinley, www.mcginleydesign.com
Chef: Khai Duong | Owner: Khai Duong & Hon Tre, LLC

891 Beach Street | San Francisco, CA 94109 | Fisherman's Wharf
Phone: +1 415 771 6800
www.anamandara.com
Opening hours: Lunch Mon–Fri 11:30 am to 2 pm, dinner Sun–Thu 5:30 pm to
9:30 pm, Fri–Sat 5:30 pm to 10:30 pm, bar & lounge every day 5 pm until closing
Average price: $ 25
Cuisine: Vietnamese, Asian
Special features: Live jazz Thu–Sat, private dining room

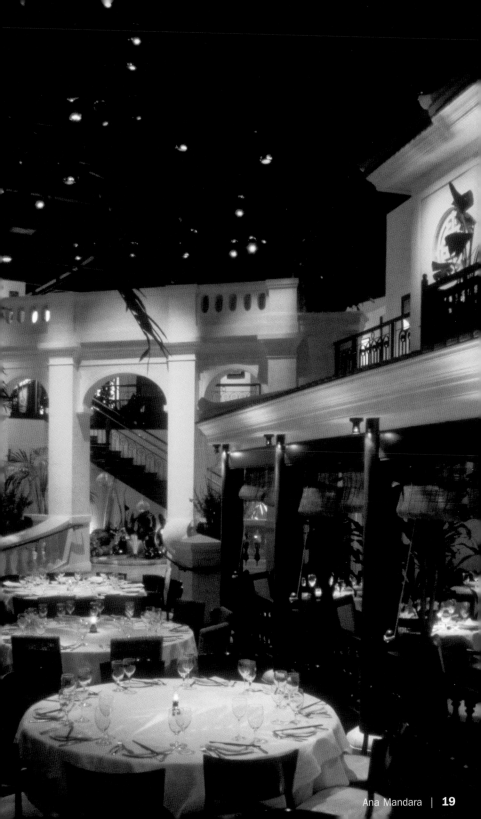

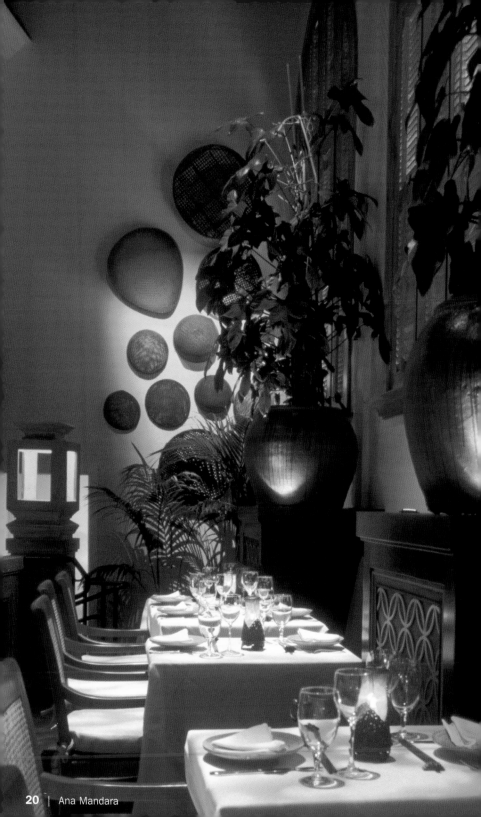

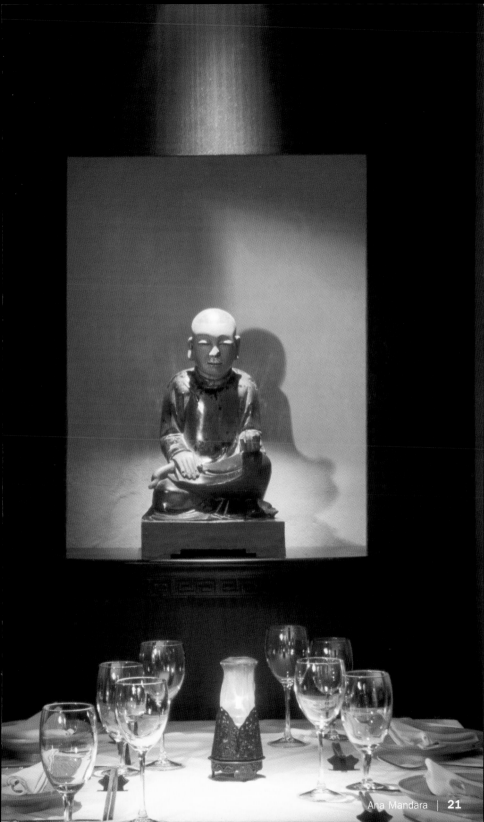

Andalu

Design: Julie Brown, Margo Chrishitiello
Chef & Owner: Calvin Schneiter

3198 16th Street | San Francisco, CA 94103 | Mission
Phone: +1 415 621 2211
www.andalusf.com
Opening hours: Sun–Tue 5:30 pm to 10 pm, Wed–Thu 5:30 pm to 11 pm,
Fri–Sat 5:30 to 11:30
Average price: $ 9
Cuisine: Californian, International
Special features: Selected wine list, wine dinners & events

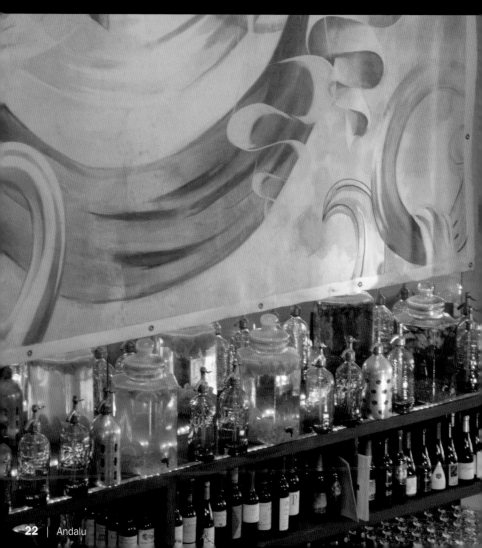

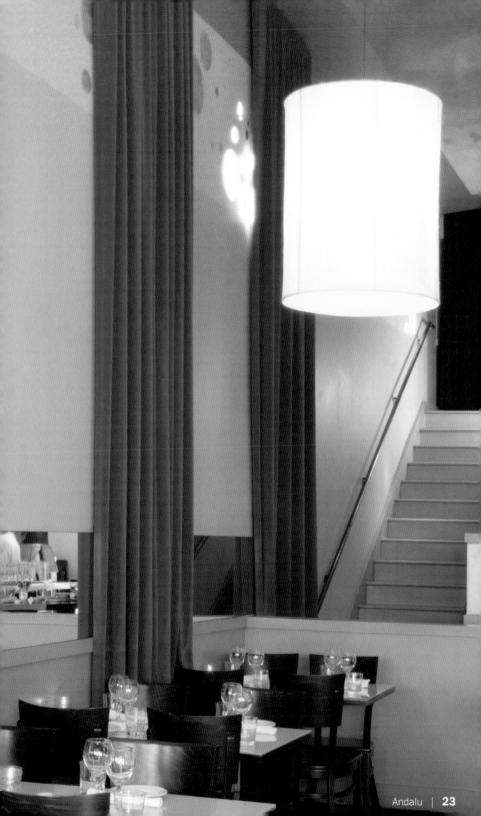

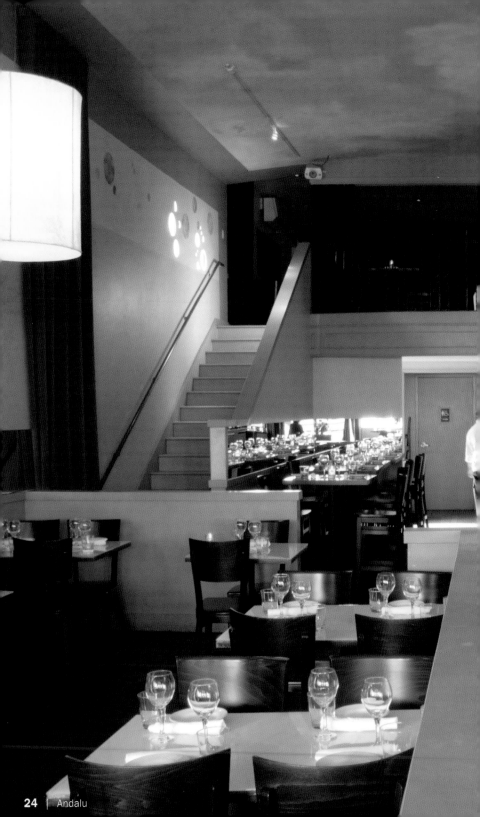

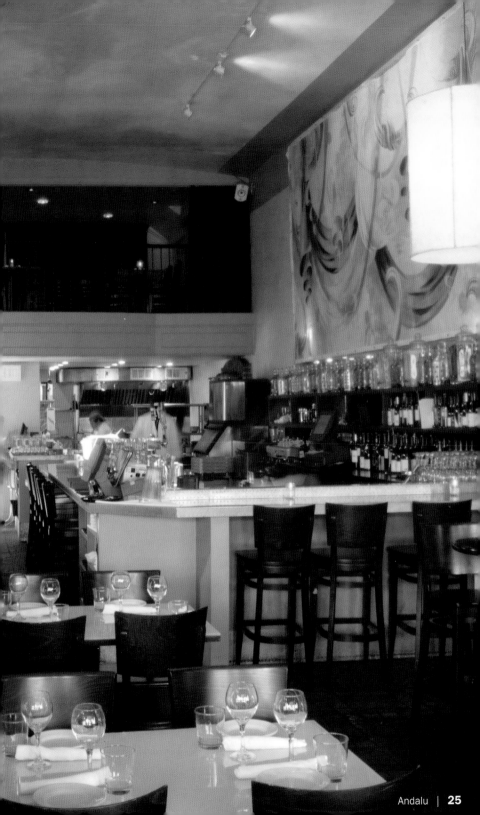

Coca-Cola Braised
Spare Ribs

Geschmorte Coca-Cola Spare Ribs

Spare ribs rôtis au coca-cola

Chuletas asadas con Coca-Cola

Costolette di maiale stufate nella
Coca-Cola

2 spare ribs (8 ribs each)
Salt and pepper
4 tbsp vegetable oil
20 oz Coca-Cola
30 oz chicken stock
2 tbsp butter

Season ribs with salt and pepper and fry them
in hot oil for approx. 5 minutes. Remove the ribs
from the pot and add the coke.
Reduce to ¼ of the original volume. Add chicken
stock and bring to the boil. Place ribs in large
roasting pan and cover with hot liquid. Braise in
pre-heated 350 °F oven for 2 hours, or until ten-
der. Remove from the oven and let the ribs cool
in the liquid. When cool, remove the ribs and cut
them into individual pieces. Strain the braising
liquid and reduce it to approx. ⅕ of its volume.
Stir in butter and season, if necessary.
To serve, reheat the ribs in the oven and coat
with a little of the sauce. Serve with white bean
salad.

2 Spare Ribs (jeweils 8 Rippchenstücke)
Salz, Pfeffer
4 EL Pflanzenöl
600 ml Coca-Cola
900 ml Geflügelbrühe
2 EL Butter

Die Spare Ribs mit Salz und Pfeffer würzen und
in heißem Öl ca. 5 Minuten anbraten. Spare
Ribs aus dem Topf nehmen und die Cola hinein-
geben.
Auf ¼ der ursprünglichen Menge reduzieren.
Geflügelbrühe dazugeben und aufkochen lassen.
Spare Ribs in eine große Fettpfanne geben und
mit der heißen Flüssigkeit bedecken. In einem auf
180 °C vorgeheizten Ofen 2 Stunden schmoren,
oder bis sie weich sind. Aus dem Ofen nehmen
und die Spare Ribs in der Flüssigkeit abkühlen
lassen. Wenn sie abgekühlt sind, herausneh-
men und in einzelne Rippchenstücke teilen. Die
Schmorflüssigkeit abseihen und auf ca. ⅕ der
Menge reduzieren. Die Butter einrühren und
eventuell abschmecken.
Zum Servieren die mit etwas Sauce überzoge-
nen Spare Ribs im Ofen erhitzen. Dazu weißen
Bohnensalat reichen.

2 spare ribs (de 8 côtes chacun)
Sel, poivre
4 c. à soupe huile végétale
600 ml de coca-cola
900 ml de bouillon de volaille
2 c. à soupe de beurre

Saler et poivrer les spare ribs et les faire frire dans l'huile chaude pendant 5 minutes environ. Retirer les spare ribs de la casserole et verser le coca. Faire réduire au $1/4$ de la quantité d'origine. Ajouter le bouillon de volaille et laisser mijoter. Mettre les spare ribs dans une grande poêle et recouvrir du liquide bouillant. Faire cuire dans un four préchauffé à 180 °C pendant 2 heures ou jusqu'à ce qu'ils soient tendres. Retirer du four et laisser refroidir les spare ribs dans le liquide. Lorsqu'ils sont refroidis, les retirer et les diviser en différents morceaux. Filtrer le liquide cuisson et réduire la quantité à $1/5$. Ajouter le beurre et éventuellement assaisonner. Avant de servir, réchauffer au four les spare ribs recouverts d'un peu de sauce. Proposer en accompagnement une salade de haricots blancs.

2 costillares de cerdo (8 chuletas cada uno)
Sal, pimienta
4 cucharadas de aceite vegetal
600 ml de Coca-Cola
900 ml de caldo de ave
2 cucharadas de mantequilla

Salpimiente las chuletas y fríalas durante 5 minutos en aceite caliente. Saque las costillas de la sartén y vierta la Coca-Cola dentro. Reduzca el líquido hasta que quede $1/4$. Añada el caldo de ave y deje que hierva. Ponga las chuletas en una bandeja de horno profunda y cúbralas con el líquido caliente. Ase la carne en un horno precalentado a 180 °C durante 2 horas hasta que esté tierna. Saque las chuletas del horno y deje que se enfríen en el líquido. Después sáquelas y sepárelas. Cuele el líquido y reserve sólo $1/5$. Incorpore la mantequilla y remueva. Si es necesario salpimiente. Antes de servir caliente la carne en el horno con un poco de la salsa. Acompañe las chuletas con una ensalada de judías blancas.

2 costolette di maiale (da tagliare poi in 8 pezzi)
Sale, pepe
4 cucchiai di olio vegetale
600 ml di Coca-Cola
900 ml di brodo di pollo
2 cucchiai di burro

Salate e pepate le costolette di maiale e fatele rosolare in olio bollente per ca. 5 minuti. Toglietele dal tegame, in cui verserete la Coca-Cola. Fate consumare il liquido fino ad ottenere $1/4$ della quantità iniziale. Aggiungete il brodo di pollo e portate ad ebollizione. Mettete le costolette in una leccarda grande e copritele con il liquido bollente. Fate stufare in forno preriscaldato a 180 °C per 2 ore oppure finché le costolette saranno tenere. Togliete le costolette dal forno e lasciatele raffreddare nel liquido. Una volta raffreddate, toglietele dal liquido e tagliate ogni costoletta in otto pezzi. Filtrate il liquido di cottura e fatelo consumare fino ad ottenere $1/5$ del quantità iniziale. Incorporatevi il burro e correggete di sapore se necessario. Prima di servire, riscaldate in forno le costolette ricoperte con un po' di salsa. Accompagnate con insalata di fagioli bianchi.

AsiaSF

Design: John Lum, www.pacificlaundry.com
Chef: Matthew Metcalf | Owners: Larry Hashbarger & Skip Young

201 Ninth Street at Howard Street | San Francisco, CA 94103 | South of Market
Phone: +1 415 255 2742
www.asiasf.com
Opening hours: Dinner Mon–Wed 6:30 pm to 10 pm, Thu & Sun 6 pm to 10 pm,
Fri 5:30 pm to 10 pm, Sat 5 pm to 10 pm
Average price: $ 35
Cuisine: Asian, Californian, fusion, eclectic
Special features: Shows hourly by the Ladies of AsiaSF, dancing until 2 am weekends

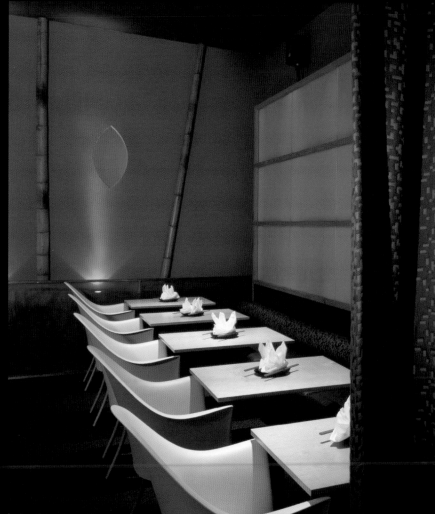

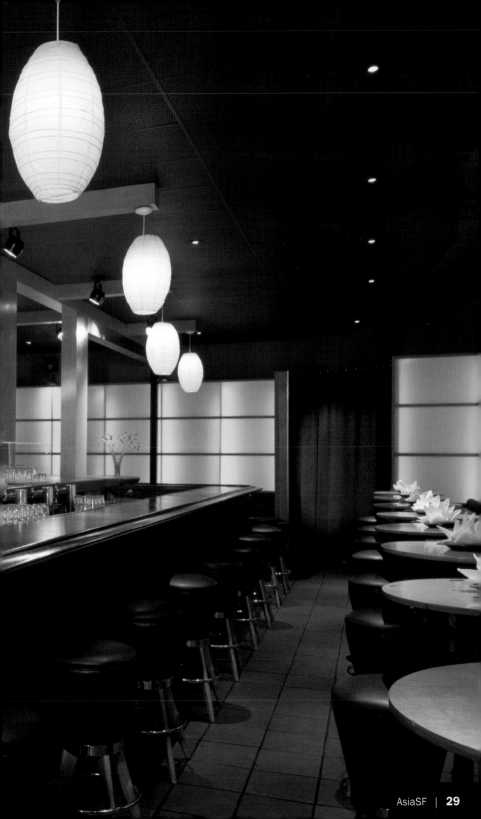

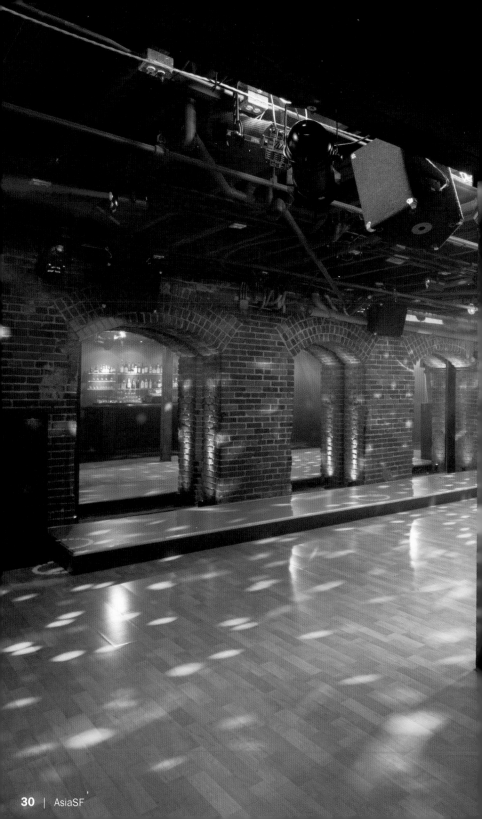

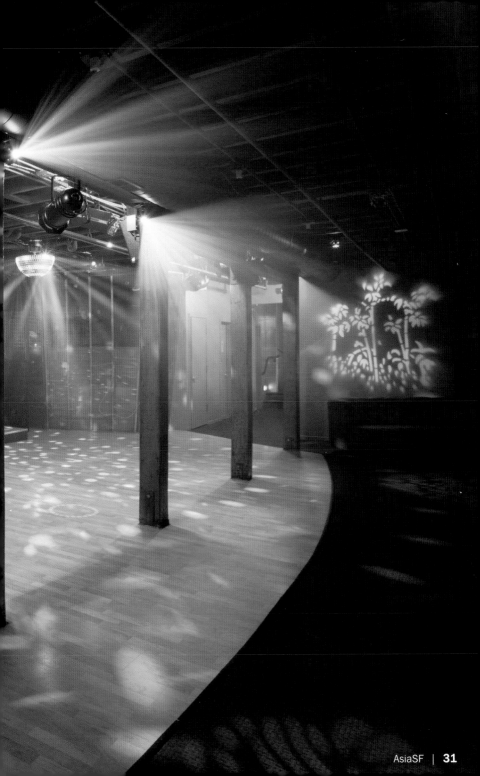

Aziza

Design: Nelson Blouncourt, www.alabastersf.com
Chef & Owner: Mourad Lahlou

5800 Geary Boulevard | San Francisco, CA 94121 | Richmond
Phone: +1 415 752 2222
www.aziza-sf.com
Opening hours: Wed–Mon 5:30 pm to 10:30 pm
Average price: $ 23
Cuisine: Moroccan, Mediterranean

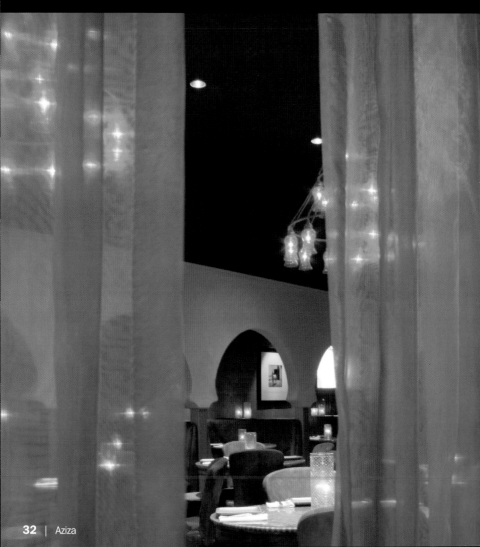

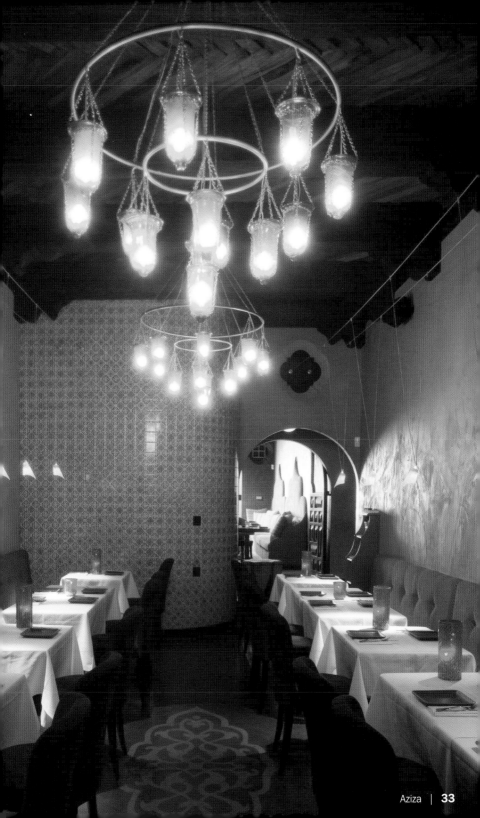

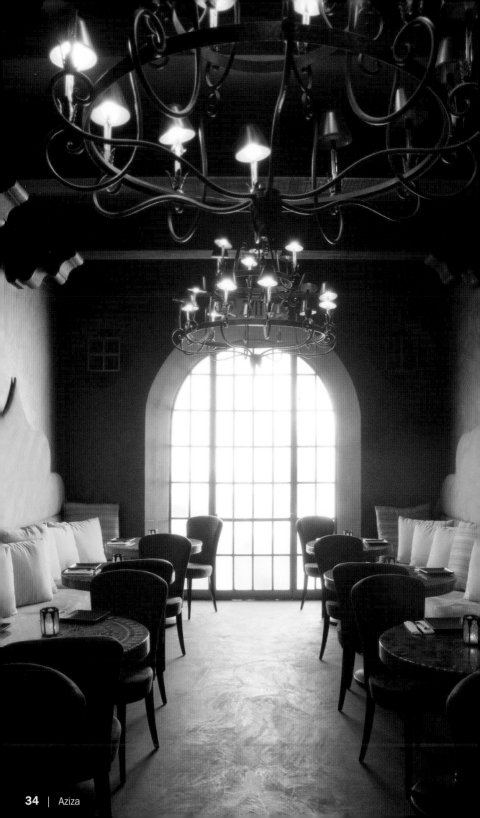

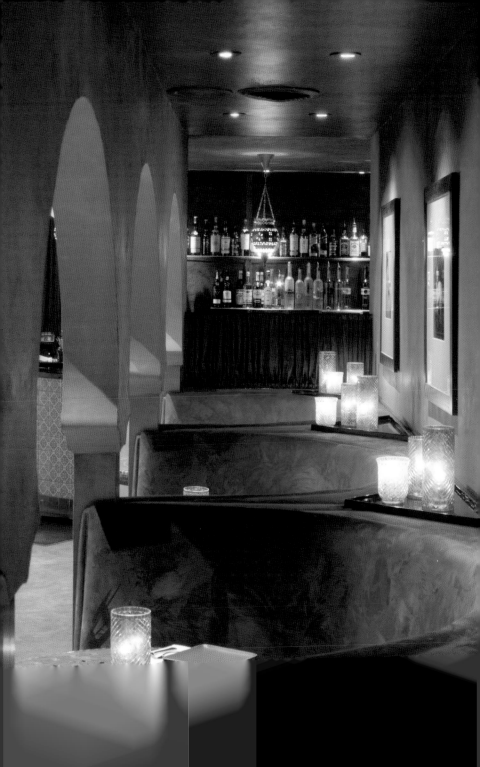

Bacar

Design: Zack Devito | Chef: Adam Timney
Owner: Arnold Eric Wong, Debbie Zachareas

448 Brannan Street | San Francisco, CA 94107 | South Beach
Phone: +1 415 904 4100
www.bacarsf.com
Opening hours: Mon–Thu 5:30 pm to 11 pm, Fri–Sat 5:30 pm to midnight,
Sun 5:30 pm to 10 pm
Average price: $ 30
Cuisine: Californian with a Mediterranean influence
Special features: Live jazz

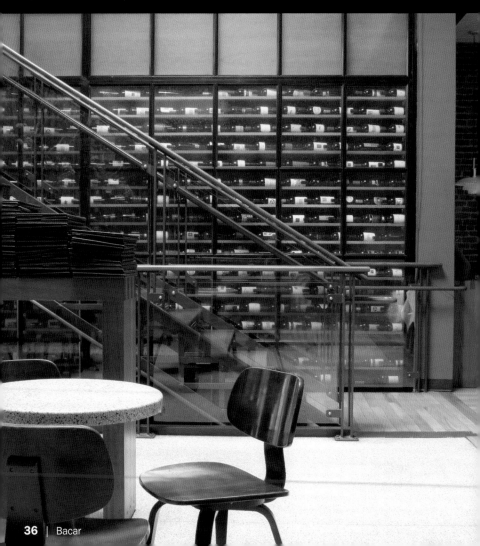

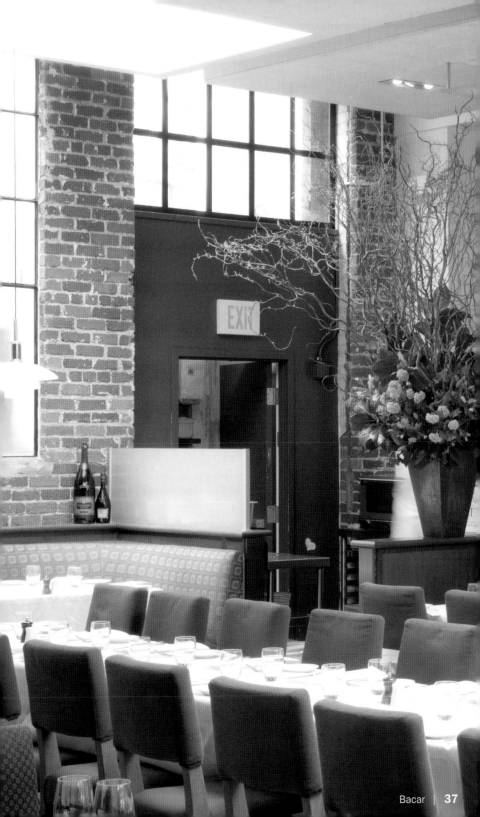

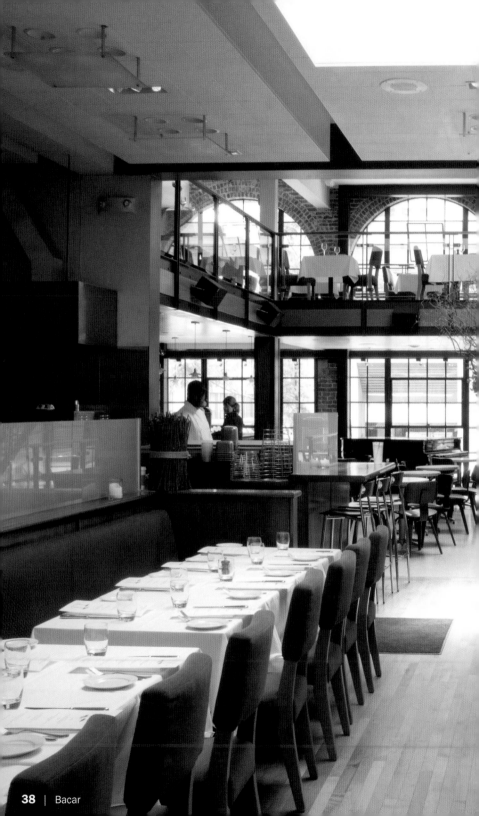

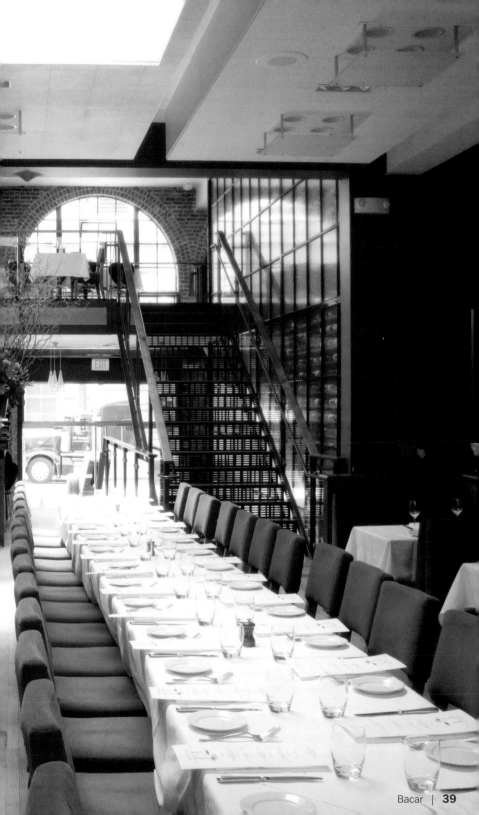

Wok Roasted Mussels

Wokgeröstete Muscheln

Moules rôties au wok

Mejillones salteados en el wok

Cozze arrostite al wok

2 lb mussels
4 tbsp olive oil
6 cloves of garlic, crushed
3 chilis, split in half lengthways
2 bay leaves
4 oz white wine
2 tsp salt
1 tsp black pepper, ground
Crusty bread, sliced and toasted

Clean and scrub the mussels under cold, running water. In a large wok, heat the oil until it begins to smoke. Quickly add the garlic and chilis. Just as the garlic begins to turn golden, add the mussels. Toss around in the wok once, allowing the mussels to reach the bottom of the wok and the garlic and chilis to come to the top. As the mussels begin to open, add the bay leaves and season with salt and pepper. Quickly glaze with white wine and stir briefly. Allow the wine to reduce, but do not overcook the mussels. As soon as the mussels are fully open, remove from the wok, transfer to a deep dish and serve with the toast.

900 g Miesmuscheln
4 EL Olivenöl
6 Knoblauchzehen, gepresst
3 Chilis, der Länge nach aufgeschnitten
2 Lorbeerblätter
120 ml Weißwein
2 TL Salz
1 TL schwarzer Pfeffer, zerstoßen
Knuspriges Brot, in Scheiben und gegrillt

Die Muscheln unter kaltem fließendem Wasser säubern und abbürsten. In einem großen Wok das Öl erhitzen, bis es zu rauchen anfängt. Schnell den Knoblauch und die Chilis hinein geben. Wenn der Knoblauch zu bräunen beginnt, die Muscheln hinzufügen. Den Wok einmal schwenken, damit die Muscheln auf den Boden des Woks rutschen und der Knoblauch und die Chilis an die Oberfläche kommen. Wenn die Muscheln anfangen sich zu öffnen, die Lorbeerblätter zugeben und mit Salz und Pfeffer würzen. Schnell mit dem Weißwein ablöschen und kurz umrühren. Den Wein reduzieren lassen, aber nicht die Muscheln zerkochen lassen. Sobald die Muscheln völlig geöffnet sind, aus dem Wok in eine tiefe Schüssel geben und mit gegrilltem Brot servieren.

900 g de moules
4 c. à soupe d'huile d'olive
6 gousses d'ail, pressées
3 piments rouges, coupés en longueur
2 feuilles de laurier
120 ml de vin blanc
2 c. à café de sel
1 c. à café de poivre noir, écrasé
Pain croustillant, en tranches et grillé

Nettoyer et frotter les moules sous l'eau froide. Chauffer l'huile dans un grand wok jusqu'à ce qu'elle commence à fumer. Ajouter rapidement l'ail et les piments rouges. Lorsque l'ail commence à brunir, ajouter les moules. Faire pivoter le wok de façon à ce que les moules glissent au fond et que l'ail et les piments rouges parviennent à la surface. Lorsque les moules commencent à s'ouvrir, ajouter les feuilles de laurier et saler et poivrer. Déglacer rapidement avec le vin blanc et remuer un bref instant. Laisser réduire le vin, mais ne pas faire bouillir les moules. Dès que les moules se sont entièrement ouvertes, les mettre dans un grand saladier et servir avec du pain grillé.

900 g de mejillones
4 cucharadas de aceite de oliva
6 dientes de ajo, majados
3 guindillas, cortadas longitudinalmente
2 hojas de laurel
120 ml de vino blanco
2 cucharaditas de sal
1 cucharaditas de pimienta negra, molida
Pan crujiente, en rebanadas y a la parrilla

Limpie los mejillones bajo el grifo con un cepillo. Caliente el aceite en el wok hasta que empiece a echar humo. Incorpore rápidamente el ajo y la guindilla. Cuando el ajo empiece a dorarse añada los mejillones. Agite una vez el wok para que los mejillones queden en el fondo y el ajo y la guindilla por encima. Cuando los mejillones empiecen a abrirse añada el laurel y salpimiente. Vierta enseguida el vino y remueva brevemente. Deje que el vino se reduzca pero evitando que los mejillones se cuezan demasiado. Cuando los mejillones estén completamente abiertos, traspáselos a un cuenco hondo y sírvalos con el pan.

900 g di cozze
4 cucchiai di olio d'oliva
6 spicchi d'aglio schiacciati
3 peperoncini tagliati in due per il lungo
2 foglie di alloro
120 ml di vino bianco
2 cucchiaini di sale
1 cucchiaino di pepe nero pestato
Pane croccante a fette e tostato alla griglia

Pulite e spazzolate le cozze sotto l'acqua corrente fredda. In un wok grande fate scaldare l'olio finché inizierà a fumare. Versatevi subito l'aglio e i peperoncini. Quando l'aglio inizia a rosolarsi, aggiungete le cozze. Fate ruotare una volta il wok per far sì che le cozze scivolino sul fondo del wok e l'aglio e i peperoncini vengano in superficie. Quando le cozze iniziano ad aprirsi, aggiungete le foglie di alloro, salate e pepate. Bagnate subito con il vino bianco e mescolate brevemente. Fate consumare il vino evitando tuttavia di fare cuocere troppo le cozze. Non appena le cozze saranno completamente aperte, toglietele dal wok e versatele in una ciotola fonda e servitele con il pane tostato alla griglia.

Baraka

Design: Baraka team work | Chef: David Bazirgan
Owners: Karine & Richard Terzaghi, Jocelyn Bulow

288 Connecticut Street | San Francisco, CA 94107 | Potrero Hill
Phone: +1 415 255 0387
www.barakasf.net
Opening hours: Every day 5:30 pm to 11 pm
Average price: $ 20
Cuisine: French, Mediterranean, fusion, eclectic
Special features: Lounge area and private room for parties

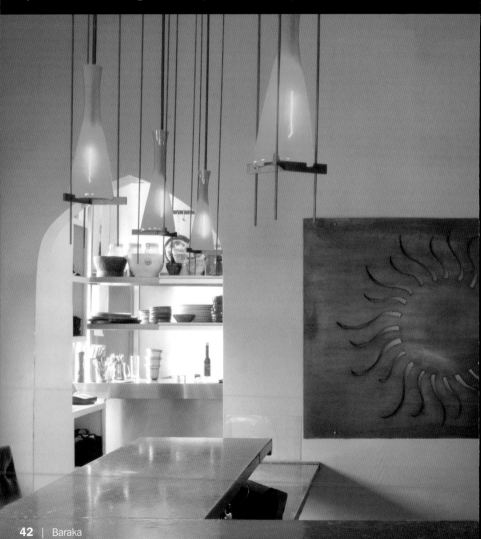

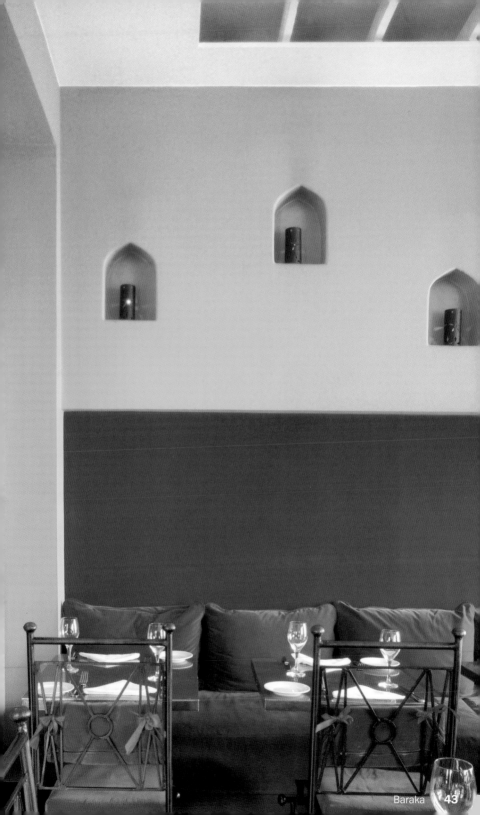

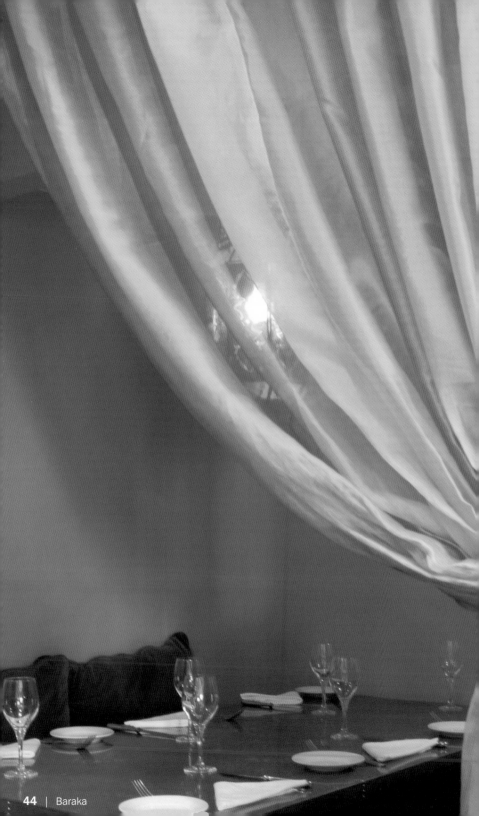

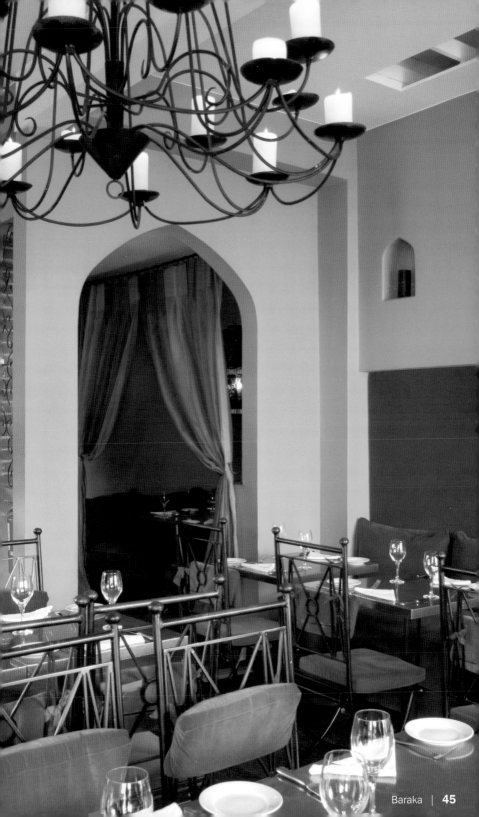

Lamb Tartare

Lammtartar

Tartare d'agneau

Tartar de cordero

Tartara di agnello

8 oz lean, minced lamb
2 egg yolks
1 tbsp red onion, diced
1 tbsp cornichons, diced
1 tsp harissa paste (African tomato paste, spicy)
1 tbsp mint leaves, chopped
1 tbsp parsley, chopped
Salt and pepper

Combine all the ingredients in a bowl and mix thoroughly. Chill for 1 hour. Evenly divide the tartare among four chilled plates. Serve with lightly dressed green beans and crackers.

240 g mageres Lammhackfleisch
2 Eigelb
1 EL rote Zwiebel, gewürfelt
1 EL Cornichons, gewürfelt
1 TL Harissapaste (Afrikanische Tomatenpaste, scharf)
1 EL Minzeblätter, gehackt
1 EL Petersilie, gehackt
Salz, Pfeffer

Alle Zutaten in eine Schüssel geben und gründlich mischen. Für 1 Stunde kaltstellen. Den Tartar gleichmäßig auf vier kalten Tellern verteilen. Mit leicht angemachten grünen Bohnen und Crackern servieren.

240 g de hachis d'agneau maigre
2 jaunes d'œuf
1 c. à soupe d'oignons rouges, coupés en dés
1 c. à soupe de cornichons, coupés en dés
1 c. à café d'harissa (pâte d'Afrique à base de
tomates, épicée)
1 c. à soupe de feuilles de menthe, hachées
1 c. à soupe de persil, haché
Sel, poivre

Mettre tous les ingrédients dans un saladier et
bien mélanger. Mettre au frais pendant 1 heure.
Disposer uniformément le tartare dans les quatre
assiettes. Servir avec des haricots verts légère-
ment assaisonnés et des biscuits salés.

240 g de carne magra de cordero
2 yemas
1 cucharada de cebolla roja en dados
1 cucharada de pepinillos en dados
1 cucharadita de pasta harisa (concentrado afri-
cano de tomate, picante)
1 cucharada de hojas de menta, picadas
1 cucharada de perejil, picado
Sal, pimienta

Ponga todos los ingredientes en un cuenco y
mézclelos bien. Déjelos enfriar durante 1 hora.
Reparta el tartar en cuatro platos fríos. Sírvalo
con judías verdes ligeramente aliñadas y pan
tostado.

240 g di carne macinata di agnello magra
2 tuorli d'uovo
1 cucchiaio di cipolla rossa tagliata a dadini
1 cucchiaio di cetriolini tagliati a dadini
1 cucchiaino di harissa (salsa di pomodoro nor-
dafricana piccante)
1 cucchiaio di foglie di menta tritate
1 cucchiaio di prezzemolo tritato
Sale, pepe

Mettete tutti gli ingredienti in una ciotola e
mescolateli bene. Mettete a raffreddare per 1 ora.
Distribuite la tartara uniformemente su quattro
piatti precedentemente raffreddati. Servite con
fagiolini leggermente conditi e cracker.

BIX

Design: Michael Gutherie | Chef: Bruce Hill
Owner: Doug Biederbeck

56 Gold Street | San Francisco, CA 94133 | Financial District
Phone: +1 415 433 6300
www.bixrestaurant.com
Opening hours: Dinner Sun–Thu 5:30 pm to 11 pm, Fri–Sat 5:30 pm to midnight,
bar 4:30 pm to closing, lunch Fri 11:30 am to 2 pm
Average price: $ 26
Cuisine: Classic American, Californian
Special features: Small and private parties, live jazz nightly, pianist, Martinis

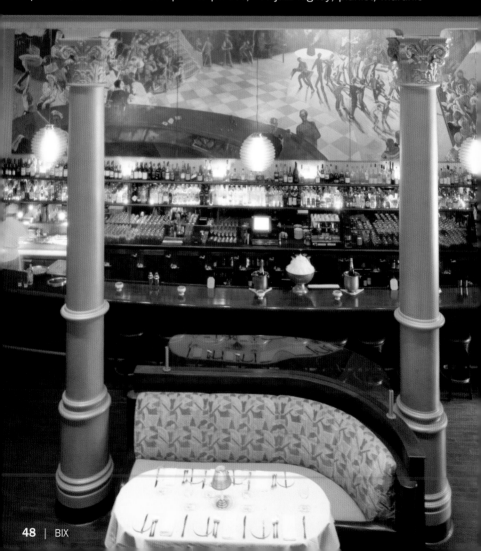

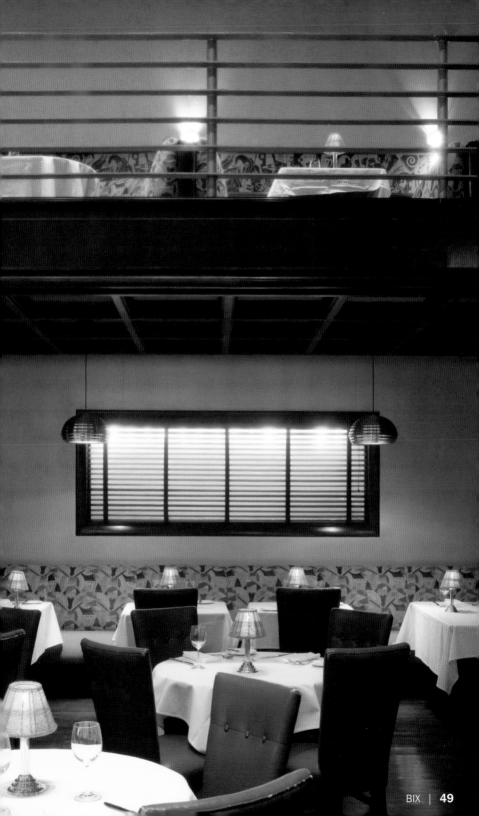

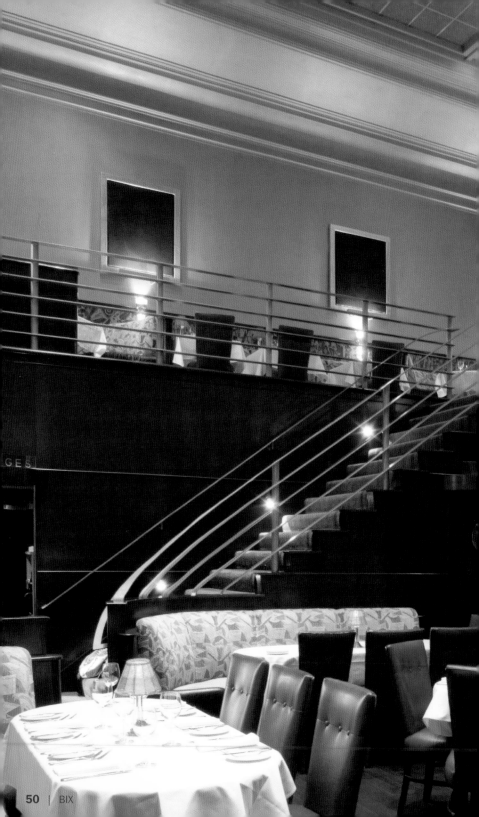

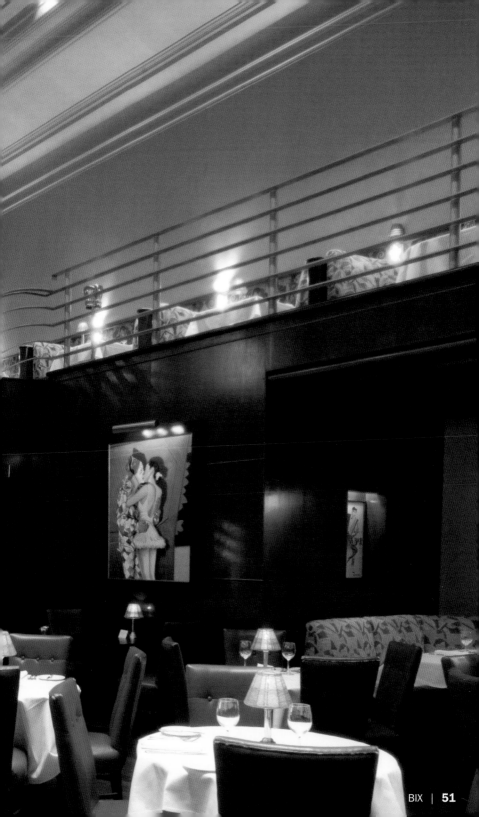

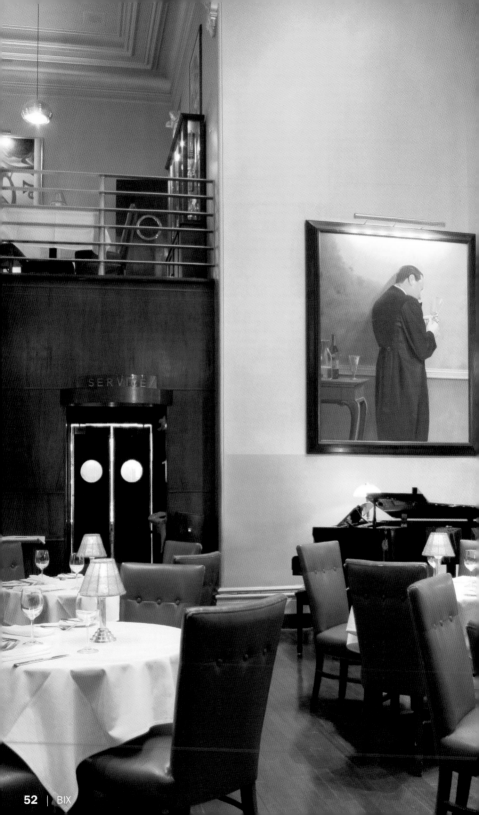

SERVICE

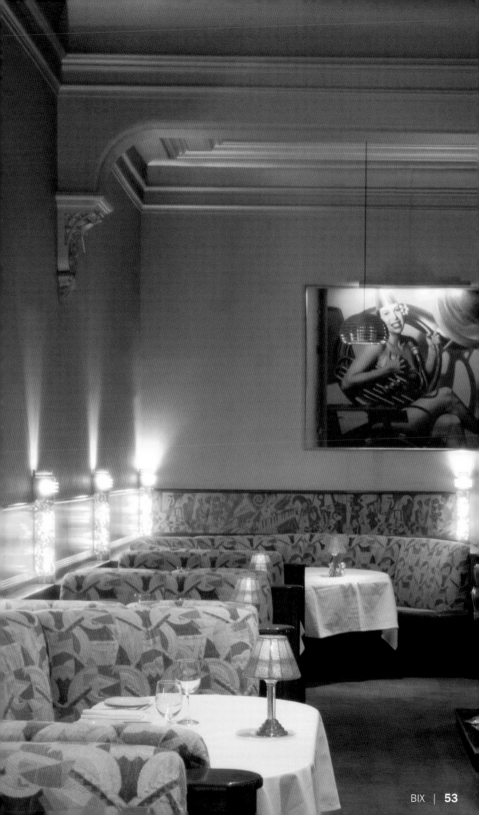

Boulevard

Design: Pat Kuleto, www.kuleto.com | Chefs: Nancy Oakes,
Pamela Mazzola | Owners: Nancy Oakes, Pat Kuleto

1 Mission Street| San Francisco, CA 94105 | Embarcadero
Phone: +1 415 543 6084
www.boulevardrestaurant.com
Opening hours: Lunch Mon–Fri 11:30 am to 2 pm, dinner Sun–Thu 5:30 pm to
10 pm, Fri–Sat 5:30 to 10:30 pm
Average price: $ 33
Cuisine: American, Californian
Special features: Semi-private room for up to 12, private dining room for groups

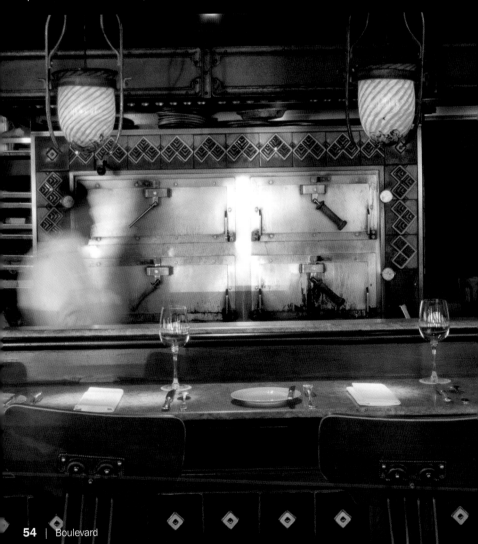

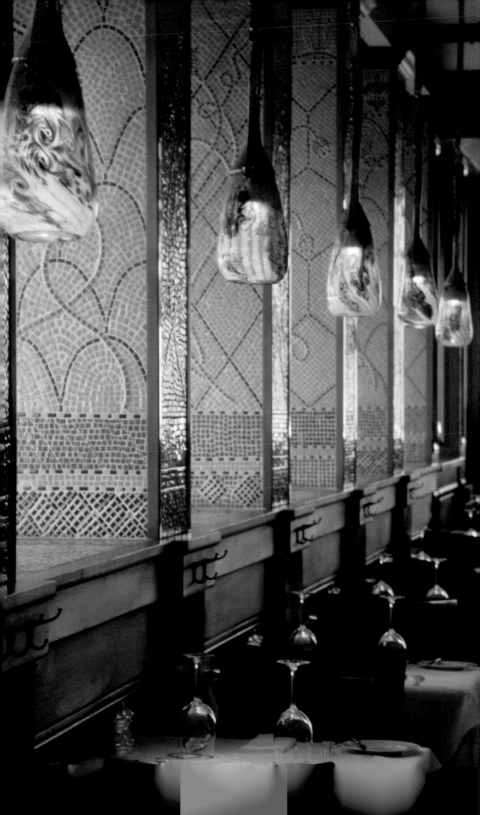

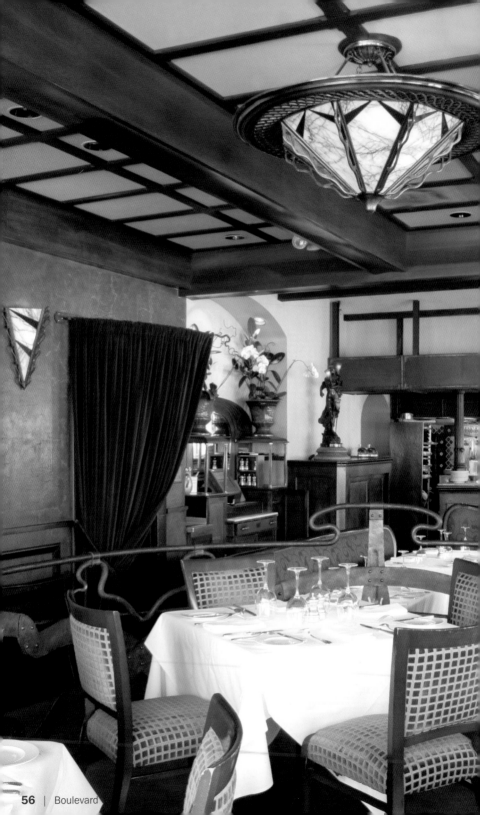

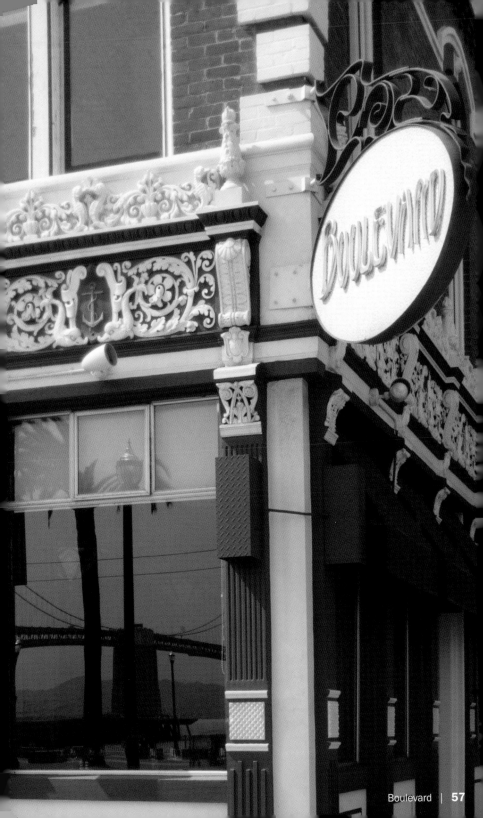

Cortez

Design: Michael Brennan | Chefs: Quinn and Karen Hatfield
Owner: Pascal Rigo

550 Geary Street | San Francisco, CA 94102 | Downtown
Phone: +1 415 292 6360
www.cortezrestaurant.com
Opening hours: Breakfast Mon–Fri 6:30 am to 10 am, Sat–Sun 6:30 am to 11 am,
dinner every day 5:30 pm to 10 pm, bar open until 1 am
Average price: $ 45
Cuisine: Creative Mediterranean, Californian
Special Features: Private dining, bar & lounge

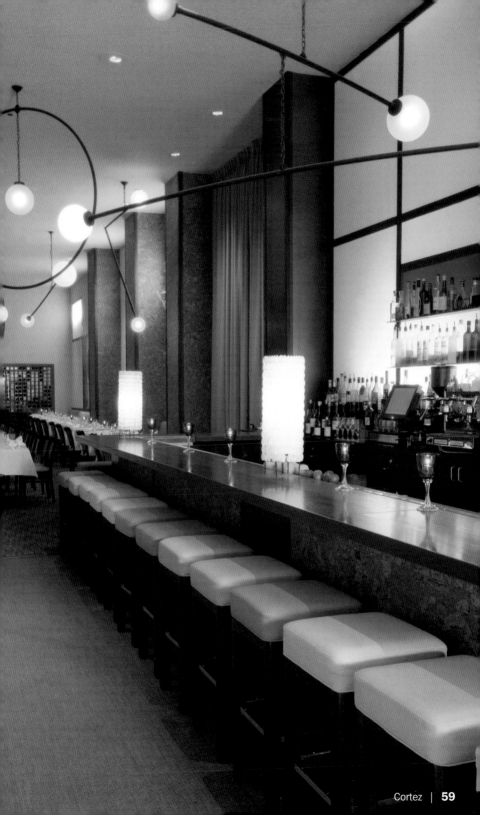

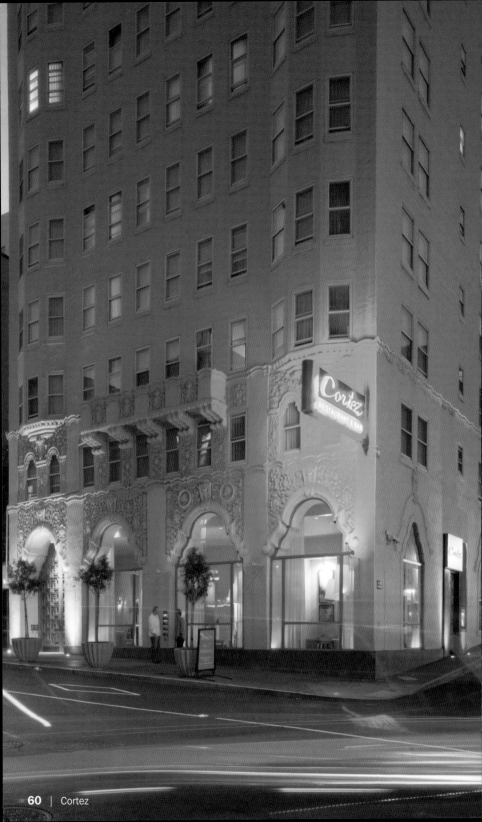

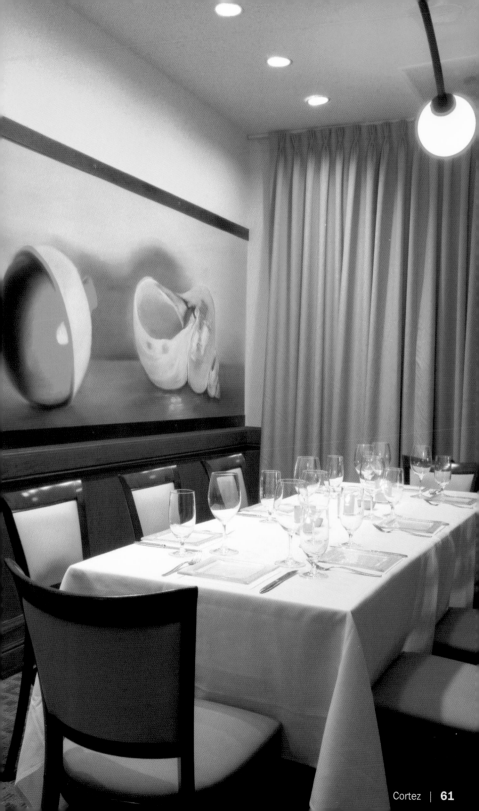

Coffee-Chocolate Fondant Tart

Kaffee-Schokoladen-Fondant-Tart

Tarte fondante au café et au chocolat

Tarta de fondant de chocolate y café

Tortino con fondant al caffè e cioccolato

Fondant:
4 oz cream
2 oz milk
6 oz corn syrup
12 oz sugar
Pinch of salt
1 tbsp coffee extract
1 tsp ground espresso
Cook the first five ingredients in a small saucepan, without stirring, until the mixture reaches 235 °F. Refrigerate for 20 minutes. Then add the coffee extract and espresso and stir with a wooden spoon. Set aside.

3 oz butter
2 oz powdered sugar
1 egg
1/2 tsp vanilla extract
1 oz cocoa powder
6 oz flour

Whisk the butter and sugar until creamy, add the egg and vanilla extract, then slowly mix in the cocoa and flour. Press into tart molds and chill for 30 minutes. Bake at 325 °F for approx. 12 minutes.

Ganache:
5 oz bittersweet chocolate, chopped
1 tbsp butter
6 oz cream
Bring cream to a boil, add the chocolate and butter and stir until smooth. Press the fondant into the bottom of the tart molds. Pour warm ganache over the fondant, then refrigerate for about 10 minutes to set. Leave at room temperature, until ready to serve. Sprinkle with sea salt and serve with your favorite ice-cream.

Fondant:
120 ml Sahne
60 ml Milch
180 ml Maissirup
360 g Zucker
Prise Salz
1 EL Kaffeeextrakt
1 TL gemahlenes Espressopulver
Die ersten fünf Zutaten in einem kleinen Topf ohne zu rühren auf 110 °C erhitzen. 20 Minuten abkühlen lassen. Dann den Kaffeeextrakt und das Espressopulver hinzufügen und mit einem Holzlöffel umrühren. Beiseite stellen.

90 g Butter
60 g Puderzucker
1 Ei
1/2 TL Vanilleextrakt

30 g Kakaopulver
180 g Mehl
Butter und Zucker cremig schlagen, Ei und Vanilleextrakt hinzufügen und den Kakao und das Mehl langsam unterrühren. In Tartförmchen drücken und für 30 Minuten kühlen. Bei 160 °C ca. 12 Minuten lang backen.

Canache:
150 Zartbitterkuvertüre, gehackt
1 EL Butter
180 ml Sahne
Sahne aufkochen, Schokolade und Butter zufügen und glatt rühren. Das Fondant in die Böden der Tartförmchen drücken. Warme Canache über das Fondant gießen, dann für 10 Minuten in den Kühlschrank stellen. Bis zum Servieren bei Zimmertemperatur lagern. Mit Meersalz bestreuen und mit der Lieblingseiscreme servieren.

Fondant:
120 ml de crème
60 ml de lait
180 ml de sirop de maïs
360 g de sucre
1 pincée de sel
1 c. à soupe d'extrait de café
1 c. à café de poudre d'expresso moulue
Faire chauffer les cinq premiers ingrédients dans une petite casserole à 110 °C, sans mélanger. Laisser refroidir pendant 20 minutes. Ajouter ensuite l'extrait de café et la poudre d'expresso et remuer à l'aide d'une cuillère en bois. Mettre de côté.

90 g beurre
60 g de sucre glace
1 œuf
1/2 c. à café d'extrait de vanille
30 g de poudre de cacao
180 g de farine

Battre le beurre et le sucre pour obtenir un mélange crémeux, ajouter l'œuf et l'extrait de vanille et incorporer lentement le cacao et la farine. Enfoncer la pâte dans des petits moules à tarte et mettre au frais pendant 30 minutes. Cuire à 160 °C pendant 12 minutes environ.

Ganache:
150 g de chocolat couverture noir, haché
1 c. à soupe de beurre
180 ml de crème
Amener la crème à ébullition, ajouter le chocolat et le beurre et mélanger pour obtenir une consistance lisse. Disposer le fondant au fond des petits moules à tarte. Verser la ganache chaude sur le fondant, puis mettre au réfrigérateur pendant 10 minutes. Conserver à température ambiante jusqu'au moment de servir. Saupoudrer de sel de mer et servir avec votre glace préférée.

Fondant:
120 ml de nata
60 ml de leche
180 ml de sirope de maíz
360 g de azúcar
1 pizca de sal
1 cucharada de extracto de café
1 cucharadita de café exprés molido
Caliente los cinco primeros ingredientes en una cazuela sin remover a 110 °C. Después déjelos enfriar durante 20 minutos. Incorpore el extracto de café y el café molido y remueva con una cuchara de madera. Reserve.

90 g de mantequilla
60 g de azúcar de lustre
1 huevo
1/2 de cucharadita de extracto de vainilla
30 g de cacao en polvo
180 g de harina

Bata la mantequilla y el azúcar hasta conseguir una mezcla cremosa. Añada el huevo, la vainilla, el cacao y la harina y remueva lentamente. Traspase la mezcla a un molde de tarta y deje que se enfríe durante 30 minutos. Hornee la masa en un horno a 160 °C durante aprox. 12 minutos.

Ganache:
150 g de cobertura de chocolate negro extrafino, desmenuzado
1 cucharada de mantequilla
180 ml de nata
Hierva la nata, añada el chocolate y la mantequilla y remueva hasta conseguir una mezcla homogénea. Extienda el fondant en la base del molde. Vierta la ganache sobre el fondant. Introduzca la tarta en el frigorífico y deje que se enfríe durante 10 minutos. Esparza por encima sal marina y sirva con su crema preferida.

Fondant:
120 ml di panna
60 ml di latte
180 ml di sciroppo di mais
360 g di zucchero
Pizzico di sale
1 cucchiaio di estratto di caffè
1 cucchiaino di polvere di caffè espresso macinato
Senza mescolare, scaldate i primi cinque ingredienti in un pentolino fino ad una temperatura di 110 °C. Lasciate raffreddare per 20 minuti. Aggiungete quindi l'estratto di caffè e la polvere di caffè espresso e mescolate con un cucchiaio di legno. Mettete da parte.

90 g di burro
60 g di zucchero a velo
1 uovo
1/2 cucchiaino di estratto di vaniglia
30 g di polvere di cacao

180 g di farina
Sbattete il burro e lo zucchero fino ad ottenere una consistenza cremosa, aggiungete l'uovo e l'estratto di vaniglia e incorporatevi a poco a poco il cacao e la farina. Foderatevi degli stampini per tortini e fate raffreddare per 30 minuti. Cuocete in forno a 160 °C per ca. 12 minuti.

Canache:
150 g di glassa di cioccolato semifondente tritata
1 cucchiaio di burro
180 ml di panna
Portate ad ebollizione la panna, aggiungete il cioccolato e il burro e mescolate bene. Pressate il fondant sui fondi degli stampini per tortini. Versate la canache calda sul fondant e mettete a raffreddare in frigorifero per 10 minuti. Lasciate poi a temperatura ambiente fino al momento di servire. Cospargete di sale marino e servite con il gelato preferito.

Delfina

Design: Douglas Burnam, www.envelopead.com
Chefs & Owners: Craig & Anne Stoll

3621 18th Street | San Francisco, CA 94110 | Mission
Phone: +1 415 552 4055
www.delfinasf.com
Opening hours: Sun–Thu 5:30 pm to 10 pm, Fri–Sat 5:30 pm to 11 pm
Average price: $ 18
Cuisine: Italian
Special features: Outdoor patio

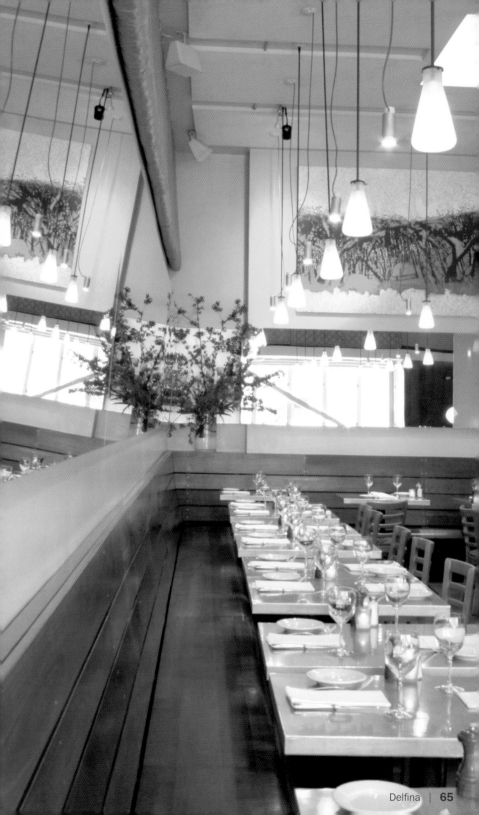

Fava Bean Crostini

with Pecorino and Lemon Oil

Favabohnen-Crostini mit Pecorino und
Zitronenöl

Crostini de fèves au pecorino et à l'huile
de citron

Crostini de habas con pecorino y aceite de
limón

Crostini di fava con pecorino e olio al limone

20 oz fresh fava beans (broad beans)
2 cloves of garlic
5 tbsp olive oil
6 oz water
Salt and pepper
8 slices country-style bread, toasted
Pecorino Romano cheese
Lemon oil

Remove the fava beans from the pods. Blanch
beans in boiling water for 3 minutes. Chill imme-
diately. Peel the beans.
Sauté the garlic in olive oil for 5 minutes on a very
low heat. Add beans and water, season with salt
and pepper and cook until the beans fall apart.
Add more water if necessary.
Drizzle the slices of toast with olive oil, season
bean purée if necessary and spread on the toast.
Garnish with flakes of Pecorino and lemon oil.
Serve with black olives and pickled onions.

600 g frische Favabohnen (Saubohnen)
2 Knoblauchzehen
5 EL Olivenöl
180 ml Wasser
Salz, Pfeffer
8 Scheiben Bauernbrot, getoastet
Pecorino Romano
Zitronenöl

Die Favabohnen aus den Schoten lösen. Die
Bohnen in kochendem Wasser blanchieren.
Sofort abschrecken. Bohnen schälen.

Knoblauch bei sehr geringer Hitze 5 Minuten
in Olivenöl anschwitzen. Die Bohnen und das
Wasser hinzugeben, mit Salz und Pfeffer würzen
und so lange kochen bis die Bohnen auseinander
fallen. Falls nötig, mehr Wasser zugeben.
Die getoasteten Brotscheiben mit Olivenöl
beträufeln, das Bohnenpüree eventuell noch-
mals abschmecken und auf das Brot streichen.
Mit Pecorinohobeln und Zitronenöl garnieren.
Mit schwarzen Oliven und eingelegten Zwiebeln
servieren.

600 g de fèves fraîches (fève des marais)
2 gousses d'ail
5 c. à soupe huile d'olive
180 ml d'eau
Sel, poivre
8 tranches de pain de campagne, grillées
Pecorino Romano
Huile de citron

Ecosser les fèves. Les faire blanchir dans l'eau bouillante. Les rafraîchir immédiatement sous l'eau froide. Décortiquer les fèves.

Faire étuver l'ail à petit feu dans l'huile d'olive pendant 5 minutes. Ajouter les fèves et l'eau, saler et poivrer et cuire jusqu'à l'obtention d'une purée de fèves. Si cela est nécessaire, ajouter plus d'eau. Arroser d'huile d'olive les tranches de pain grillé, assaisonner éventuellement de nouveau la purée de fèves et étaler sur le pain. Garnir de pecorino râpé et d'huile de citron. Servir avec des olives noires et des oignons au vinaigre.

600 g de habas frescas
2 dientes de ajo
5 cucharadas de aceite de oliva
180 ml de agua
Sal, pimienta
8 rebanadas de pan moreno, tostadas
Queso pecorino romano
Aceite de limón

Saque las habas de las vainas y escáldelas. Sumérjalas después en agua con hielo para parar la cocción y pélelas. Sofría el ajo en aceite de oliva a fuego muy lento durante 5 minutos. Incorpore las habas y el agua, salpimiente y siga cociendo hasta que las habas se deshagan. Si es necesario añada más agua. Vierta el aceite de oliva por encima de las tostadas. Si lo desea salpimiente nuevamente el puré de habas y unte con él el pan. Adorne con el queso pecorino rallado y el aceite de limón. Sirva con aceitunas negras y cebollas encurtidas.

600 g di fave fresche
2 spicchi d'aglio
5 cucchiai di olio d'oliva
180 ml di acqua
Sale, pepe
8 fette di pane casereccio tostato
Pecorino romano
Olio al limone

Separate le fave dal baccello e sbollentatele in acqua bollente. Raffreddatele subito con dell'acqua e privatele della pellicina.

Fate dorare l'aglio nell'olio d'oliva a fuoco molto basso per 5 minuti. Aggiungete le fave e l'acqua, salate e pepate e fate cuocere finché le fave si sbricioleranno. Se necessario, aggiungete altra acqua. Versate alcune gocce di olio d'oliva sulle fette di pane tostate, correggete eventualmente di nuovo il condimento della purea di fave e spalmatela sul pane. Guarnite con scaglie di pecorino e olio al limone. Servite con olive nere e cipolle sottaceto.

Farallon

Design: Pat Kuleto, www.kuleto.com
Chef: Mark Franz | Owner: Mark Franz, Pat Kuleto

450 Post Street | San Francisco, CA 94102 | Union Square
Phone: +1 415 956 6969
www.farallonrestaurant.com
Opening hours: Lunch Tue–Sat 11:30 am to 2:30 pm, dinner Mon–Thu 5:30 pm to
10 pm, Fri–Sat 5:30 pm to 11 pm, Sun 5 pm to 10 pm, bistro Tue–Sat 2:30 pm to 5 pm
Average price: $ 32
Cuisine: Coastal cuisine
Special features: Daily changing menu

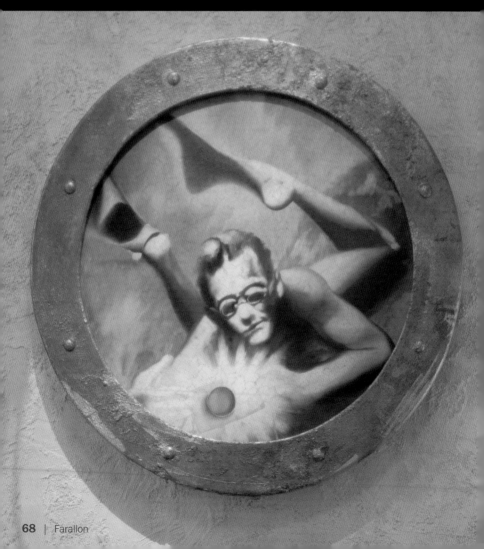

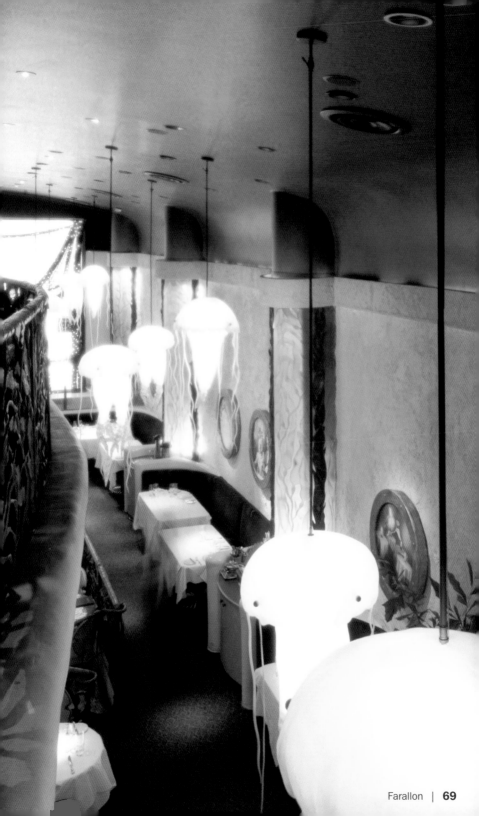

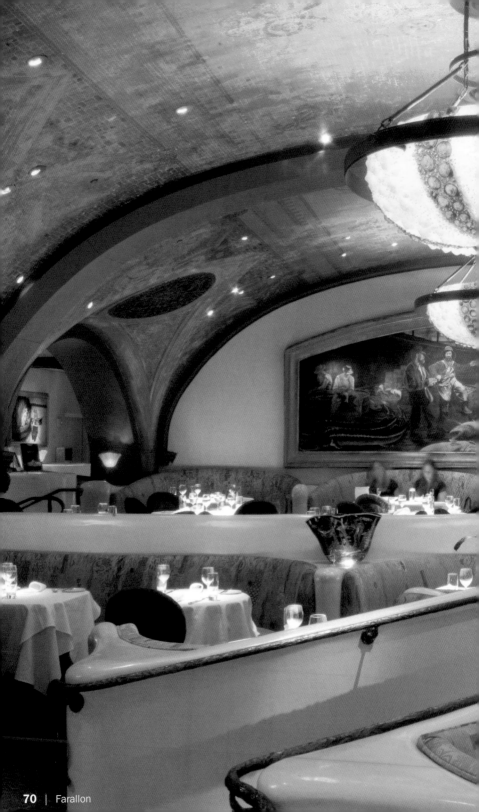

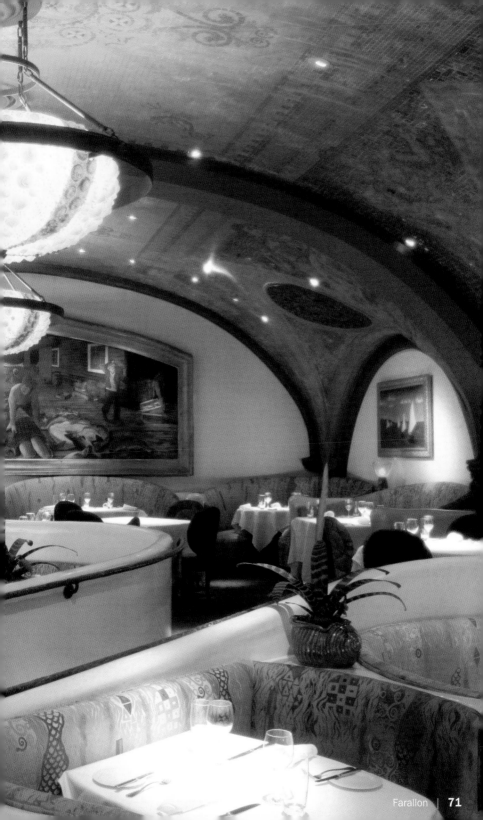

Fifth Floor

Design: Cheryl Rowley, Bob La Cour, www.cherylrowley.com
Chef: Melissa Perello | Owner: Kimpton Group

12 Fourth Street | San Francisco, CA 94103 | Union Square
Phone: +1 415 348 1555
www.fifthfloor.citysearch.com
Opening hours: Mon–Thu 5:30 pm to 9:30 pm, Fri–Sat 5:30 pm to 10:30 pm,
Sun closed
Average price: $ 35
Cuisine: Modern French
Special features: Private banquet room, lounge

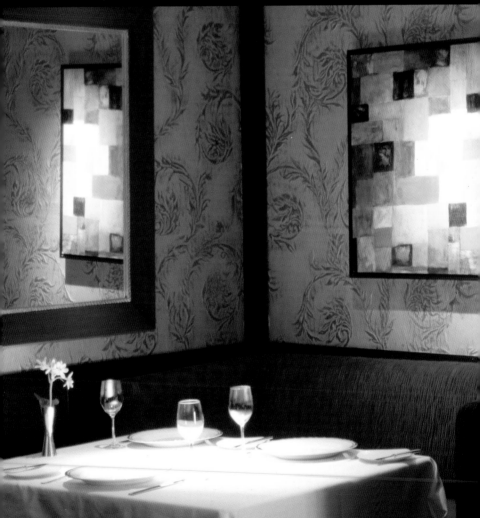

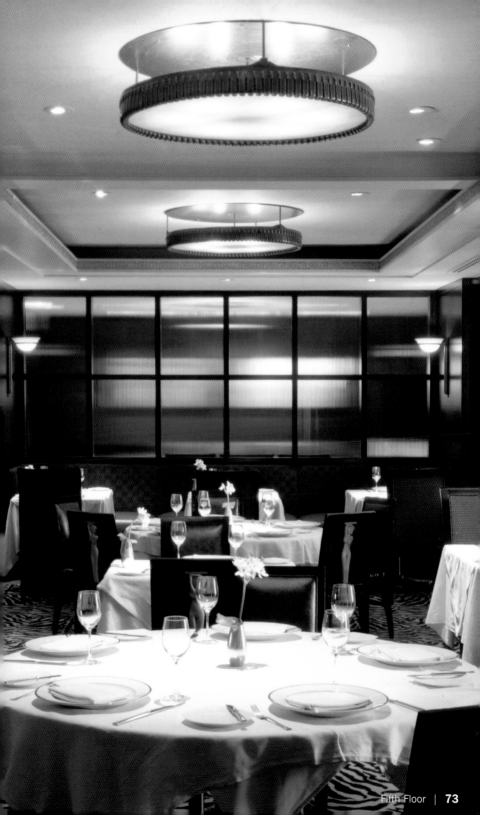

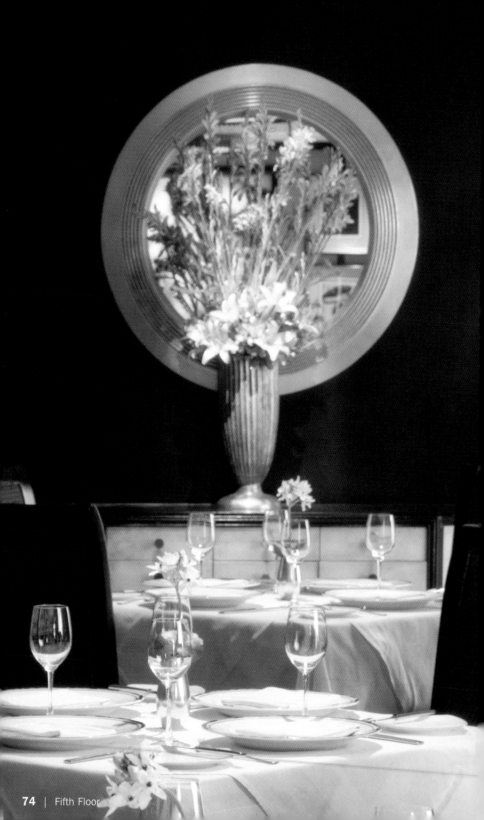

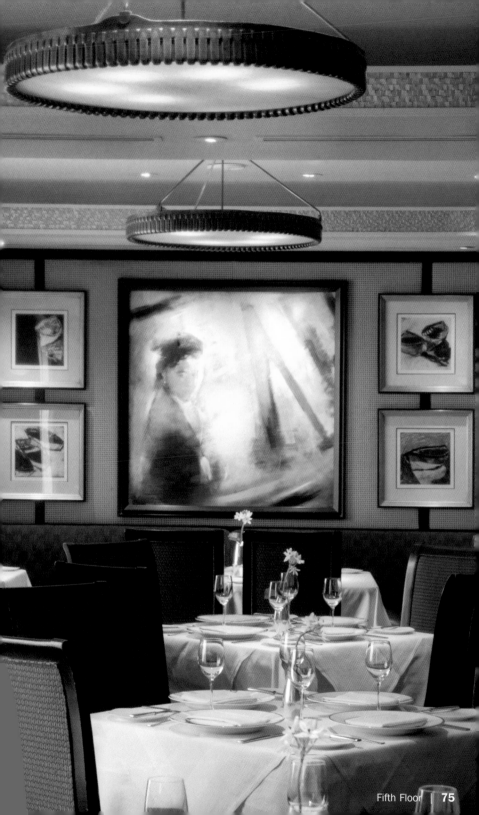

Tasmanian Trout

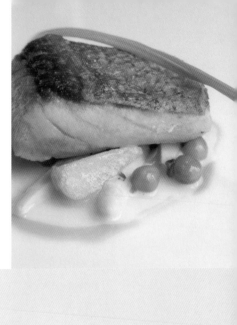

Tasmanische Forelle

Truites de Tasmanie

Truchas de Tasmania

Trota tasmaniana

4 Tasmanian trouts, 6 oz each
4 tbsp butter
Salt and pepper
6 oz lemon juice
1 tbsp honey
3 oz water
8 oz vegetable oil

Combine lemon juice, honey and water in a food mixer and blend at high speed. Slowly add the oil. Blend until the mixture begins to thicken. Season and chill.
Season the trout and sear in a very hot pan on both sides for 2–3 minutes.
Spoon lemon sauce on four plates, place the trouts in the middle and garnish with peas and carrots.

4 Tasmanische Forellen zu je 180 g
4 EL Butter
Salz, Pfeffer
180 ml Zitronensaft
1 EL Honig
90 ml Wasser
240 ml Pflanzenöl

Zitronensaft, Honig und Wasser in einen Mixer geben und auf höchster Stufe mixen. Langsam das Öl zugeben. So lange mixen, bis die Mischung andickt. Würzen und kaltstellen.
Forellenstücke würzen und in einer sehr heißen Pfanne auf beiden Seiten 2–3 Minuten scharf anbraten.
Zitronensauce auf vier Tellern verteilen, die Forellen in die Mitte legen und mit Erbsen und Möhren garnieren.

4 truites de Tasmanie de 180 g chacune
4 c. à soupe de beurre
Sel, poivre
180 ml de jus de citron
1 c. à soupe de miel
90 ml d'eau
240 ml d'huile végétale

Mettre dans un mixer le jus de citron, le miel et l'eau et mixer à la puissance maximale. Ajouter l'huile lentement. Mixer jusqu'à temps que le mélange épaississe. Assaisonner et mettre au frais.
Assaisonner les truites et les faire frire des deux côtés sans matière grasse dans une poêle très chaude pendant 2–3 minutes.
Disposer la sauce au citron sur quatre assiettes, placer les truites au milieu et garnir de petits pois et de carottes.

4 truchas de Tasmania, de 180 g cada una
4 cucharadas de mantequilla
Sal, pimienta
180 ml de zumo de limón
1 cucharada de miel
90 ml de agua
240 ml de aceite vegetal

Mezcle el zumo de limón, la miel y el agua en un robot de cocina a la potencia máxima. Incorpore poco a poco el aceite. Siga batiendo hasta que la mezcla se espese. Salpimiente y resérvela fría.
Salpimiente las truchas y fríalas en una sartén muy caliente durante 2–3 minutos por cada lado.
Reparta la salsa de limón en cuatro platos, coloque en el centro las truchas y adorne con guisantes y zanahoria.

4 trote tasmaniane da 180 g l'una
4 cucchiai di burro
Sale, pepe
180 ml di succo di limone
1 cucchiaio di miele
90 ml di acqua
240 ml di olio vegetale

Mettete il succo di limone, il miele e l'acqua in un mixer e frullate a velocità massima. Aggiungete lentamente l'olio. Frullate finché il composto si sarà ispessito. Condite e mettete a raffreddare.
Condite i pezzi di trota e fateli rosolare bene da entrambi i lati in una padella bollente per 2–3 minuti.
Distribuite la salsa al limone su quattro piatti, mettete le trote al centro e guarnite con piselli e carote.

Foreign Cinema

Design: Praxis | Chefs: John Clark, Gayle Pirie
Owners: Bruce Mc Donald, John Clark, Gayle Pirie

2534 Mission Street | San Francisco, CA 94110 | Mission
Phone: +1 415 648 7600
www.foreigncinema.com
Opening hours: Mon–Fri 6 pm to 10 pm, Sat 11 am to 11 pm, Sun 11 am to 10 pm
Average price: $ 21
Cuisine: Californian, Mediterranean
Special features: Movies while dining, Laszlo Bar, brunch

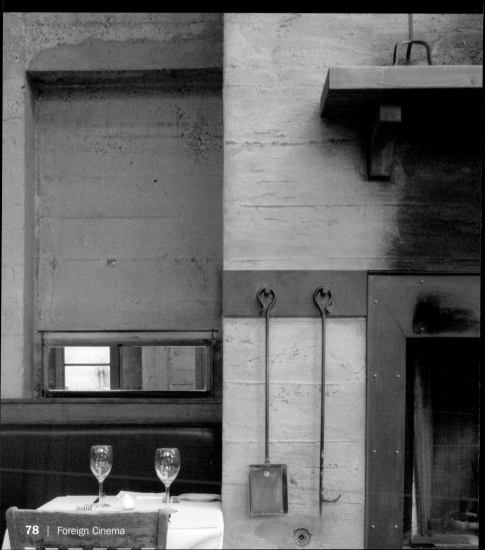

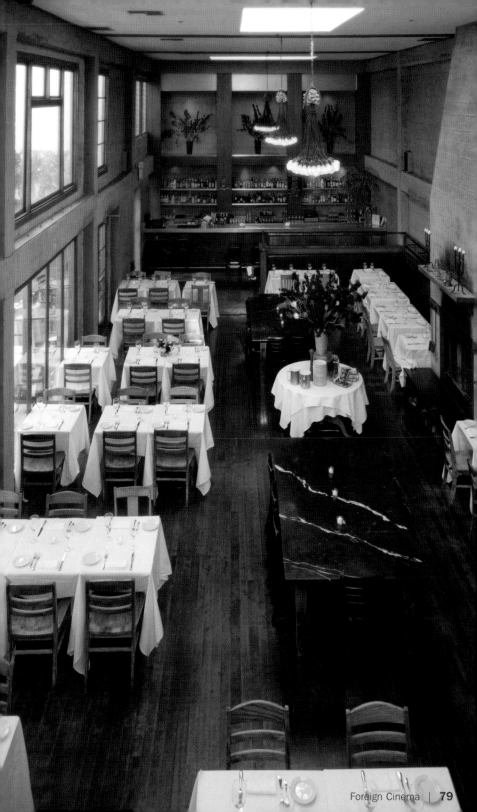

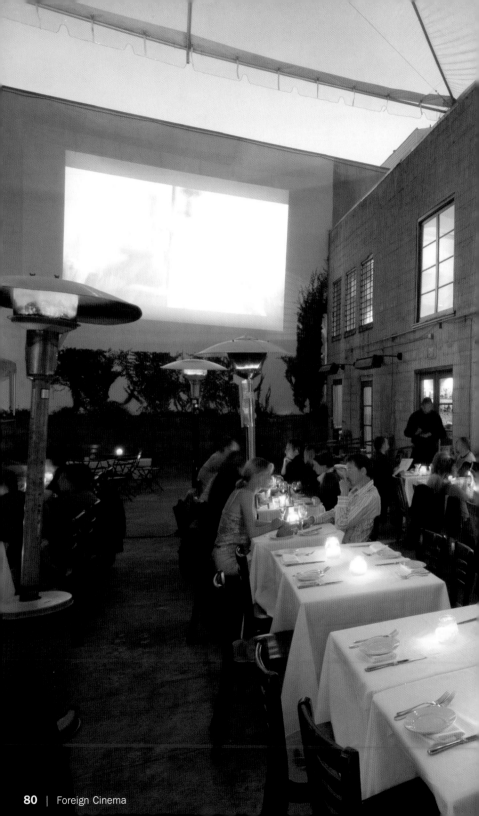

Warm Pavé d'Affinois

Warmer Pavé d'Affinois
Pavé d'Affinois chaud
Pavé d'affinois caliente
Pavé d'Affinois caldo

2 Pavé d'Affinois (square brie-like cheese)
4 medium potatoes
3 tbsp olive oil
Salt
8 dill pickles
Black and green olives

Preheat oven to 375 °F. Cut potatoes in wedges, rub with olive oil and salt and place in the bottom of the oven. Cut both cheeses in half, place cheese with the cut side up on a baking sheet and place in the center of the pre-heated oven. Bake for 10 minutes, or until the cheese is completely melted and lightly brown. Remove cheese and potatoes from oven and serve with dill pickles and olives.

2 Pavé d'Affinois (eckiger Brie-ähnlicher Käse)
4 mittlere Kartoffeln
3 EL Olivenöl
Salz
8 Dillgurken
Schwarze und grüne Oliven

Den Ofen auf 190 °C vorheizen. Kartoffeln in Spalten schneiden, mit Olivenöl und Salz einreiben und auf die untere Schiene des Ofens geben. Beide Käse halbieren, mit der Schnittfläche nach oben auf ein Backblech setzen und in die Mitte des vorgeheizten Ofens geben. 10 Minuten backen oder bis der Käse komplett geschmolzen und leicht gebräunt ist. Käse und Kartoffeln aus dem Ofen nehmen und mit Dillgurken und Oliven servieren.

2 pavés d'Affinois
4 pommes de terre de taille moyenne
3 c. à soupe d'huile d'olive
Sel
8 concombres
Olives noires et vertes

Préchauffer le four à 190 °C. Couper les pommes de terre in lamelles, les frotter d'huile à l'huile d'olive et au sel et les placer sur la plaque inférieure du four. Diviser les fromages en deux, les placer sur une plaque la croûte vers le bas et mettre au milieu du four préchauffé. Cuire pendant 10 minutes ou jusqu'à ce que le fromage soit complètement fondu et ait légèrement bruni. Retirer les fromages et les pommes de terre du four et servir avec des concombres et des olives.

2 quesos pavé d'affinois (similar al queso brie triangular)
4 patatas medianas
3 cucharadas de aceite de oliva
Sal
8 pepinillos en vinagre al eneldo
Aceitunas negras y verdes

Precaliente el horno a 190 °C. Corte las patatas en porciones, úntelas con el aceite y condiméntelas con la sal. Coloque las porciones en la bandeja inferior del horno. Corte los quesos en mitades y colóquelas en una bandeja sobre la superficie del corte. Ponga la bandeja en los rieles del centro del horno precalentado. Hornee durante 10 minutos o hasta que el queso se haya derretido y esté dorado. Saque las patatas y el queso del horno y adorne con los pepinillos y las aceitunas.

2 Pavé d'Affinois (formaggio simile al Brie dalla forma quadrata)
4 patate medie
3 cucchiai di olio d'oliva
Sale
8 cetrioli all'aneto
Olive nere e verdi

Preriscaldate il forno a 190 °C. Tagliate le patate a spicchi, sfregatele con olio d'oliva e sale e mettetele nella parte più bassa del forno. Dividete i due formaggi a metà, metteteli su una piastra da forno con la superficie tagliata rivolta verso l'alto e passateli in forno preriscaldato collocandoli a metà altezza. Fate cuocere in forno per 10 minuti oppure finché il formaggio si sarà completamente sciolto e sarà appena dorato. Togliete il formaggio e le patate dal forno e servite con cetrioli all'aneto e olive.

Gary Danko

Design: Sandy Walker | Chef & Owner: Gary Danko

800 North Point Street | San Francisco, CA 94109 | Lower Russian Hill
Phone: +1 415 749 2060
www.garydanko.com
Opening hours: Every day dinner 5:30 pm to 10 pm, bar 5 pm to midnight
Menu price: $ 69
Cuisine: Modern & classic
Special features: Five star rating, private dining room

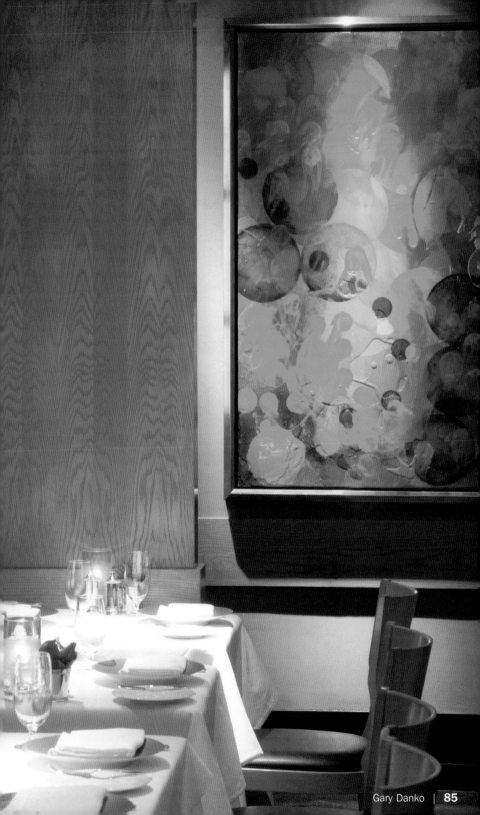

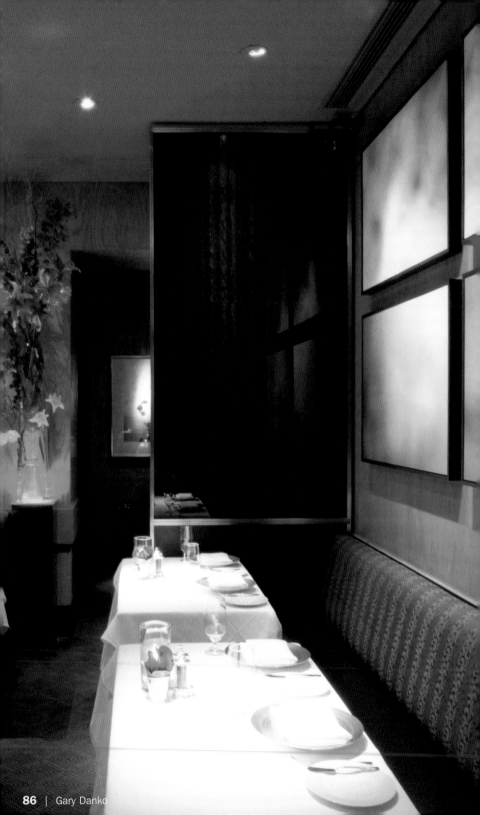

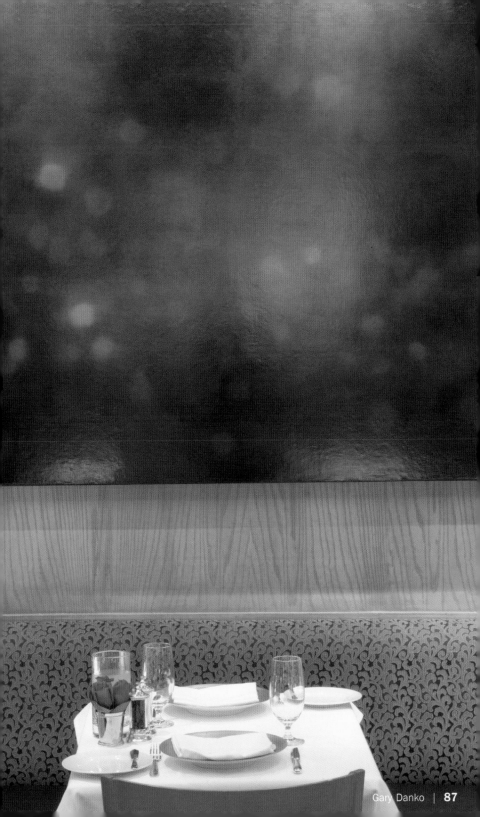

Maine Lobster
with Asparagus and Morrels

Maine-Hummer mit Spargel und Morcheln

Homards du Maine aux asperges et aux morilles

Langosta de Maine con espárragos y colmenillas

Astice del Maine con asparagi e spugnole

2 lobster
4 oz white wine
2 oz fish stock
1 shallot, diced
1 bay leaf
1 sprig of thyme
2 oz cream
8 tbsp butter
2 tbsp parsley, chopped
1 tbsp chervil, chopped
2 tbsp chives, chopped
1 tsp lemon juice
12 asparagus tips, steamed
16 morrels, sautéed
Mashed potatoes

Cook lobster in boiling, salted water for approx. 5 minutes. Chill immediately. Crack the shell and remove the flesh. Set aside. Combine white wine, fish stock, shallot, bay leaf and thyme in a pot and reduce to 1/3. Strain, then add cream, butter, asparagus tips, morrels, herbs and lemon juice. Season to taste.
Place the lobster meat on the mashed potatoes, using parts of the shell as decoration and garnish with vegetables and fresh herbs. Drizzle with sauce.

2 Hummer
120 ml Weißwein
60 ml Fischfond
1 Schalotte, gewürfelt
1 Lorbeerblatt
1 Zweig Thymian
60 ml Sahne
8 EL Butter
2 EL Petersilie, gehackt
1 EL Kerbel, gehackt
2 EL Schnittlauch, gehackt
1 TL Zitronensaft
12 Spargelspitzen, gedämpft
16 Morcheln, angeschwitzt
Kartoffelpüree

Die Hummer für ca. 5 Minuten in kochendem Wasser blanchieren. Sofort abschrecken. Den Panzer aufbrechen und das Fleisch entfernen. Beiseite stellen. Weißwein, Fischfond, Schalotte, Lorbeerblatt und Thymian in einen Topf geben und auf 1/3 reduzieren. Abseihen, dann Sahne, Butter, Spargelspitzen, Morcheln, Kräuter und Zitronensaft hinzufügen. Abschmecken.
Das Hummerfleisch auf dem Kartoffelpüree anrichten, Teile des Panzers als Dekoration benutzen, und mit Gemüse und Kräutern garnieren. Mit der Sauce beträufeln.

2 homards
120 ml de vin blanc
60 ml de fumet de poisson
1 échalote, en dés
1 feuille de laurier
1 branche de thym
60 ml de crème
8 c. à soupe de beurre
2 c. à soupe de persil, haché
1 c. à soupe de cerfeuil, haché
2 c. à soupe de ciboulette, hachée
1 c. à café de jus de citron
12 pointes d'asperges, étuvées
16 morilles, suées
Purée de pommes de terre

Faire blanchir les homards pendant 5 minutes environ dans l'eau bouillante. Les rafraîchir immédiatement sous l'eau froide. Briser la carapace et extraire la chair. Mettre de côté. Mettre dans une casserole le vin blanc, le fumet de poisson, échalote, feuille de laurier et le thym et faire réduire au $1/3$. Filtrer, puis ajouter la crème, le beurre, les pointes d'asperges, les morilles, les herbes et le jus de citron. Assaisonner. Disposer la chair du homard sur la purée de pommes de terre, utiliser les morceaux de carapace pour décorer, et garnir de légumes et d'herbes. Arroser de sauce.

2 langostas
120 ml de vino blanco
60 ml de caldo de pescado
1 chalote, en dados
1 hoja de laurel
1 ramita de tomillo
60 ml de nata
8 cucharadas de mantequilla
2 cucharadas de perejil, picado
1 cucharada de perifollo, picado
2 cucharadas de cebollino, picado
1 cucharadita de zumo de limón
12 puntas de espárragos, cocidas
16 colmenillas, rehogadas
Puré de patata

Escalde las langostas durante 5 minutos. Sumérjalas después en agua con hielo. Rompa los caparazones y extraiga la carne. Resérvela. Ponga en una cazuela el vino blanco, el caldo de pescado, el chalote, el laurel y el tomillo y cueza hasta que quede $1/3$ del líquido. Cuele el caldo y añada la nata, la mantequilla, las puntas de los espárragos, las colmenillas, las hierbas y el zumo de limón. Salpimiente. Ponga el puré en los platos, coloque encima la carne y utilice trozos de los caparazones, la verdura y las hierbas para adornar. Vierta por encima la salsa.

2 astici
120 ml di vino bianco
60 ml di fondo di pesce
1 scalogno tagliato a dadini
1 foglia di alloro
1 rametto di timo
60 ml di panna
8 cucchiai di burro
2 cucchiai di prezzemolo tritato
1 cucchiaio di cerfoglio tritato
2 cucchiai di erba cipollina tritata
1 cucchiaino di succo di limone
12 punte di asparagi cotte a vapore
16 spugnole fatte dorare
Purè di patate

Sbollentate gli astici in acqua bollente per ca. 5 minuti. Raffreddateli subito con dell'acqua. Rompete la corazza e togliete la carne. Mettete da parte. In una pentola mettete il vino bianco, il fondo di pesce, lo scalogno, la foglia di alloro e il timo e fate consumare fino ad ottenere $1/3$ della quantità iniziale. Filtrate e aggiungetevi la panna, il burro, le punte di asparagi, le spugnole, le erbe e il succo di limone. Correggete di sapore. Disponete la carne di astice sul purè di patate, usate pezzi di corazza come decorazione, e guarnite con verdura ed erbe. Versatevi alcune gocce della salsa.

Greens Restaurant

Chef: Annie Somerville | Owner: San Francisco Zen Center

Fort Mason, Building A | San Francisco, CA 94123 | Marina
Phone: +1 415 771 6222
www.greensrestaurant.com
Opening hours: Dinner Mon–Sat 5:30 pm to 9 pm, lunch Tue–Sat noon to 2:30 pm,
brunch Sun 10:30 am to 2 pm
Average price: $ 18
Cuisine: Vegetarian
Special features: View of Golden Gate Bridge

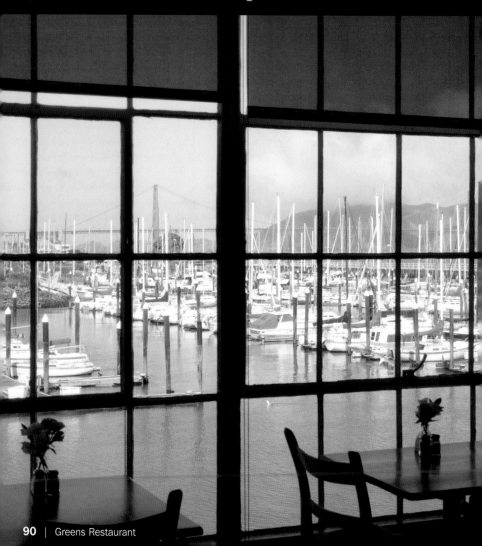

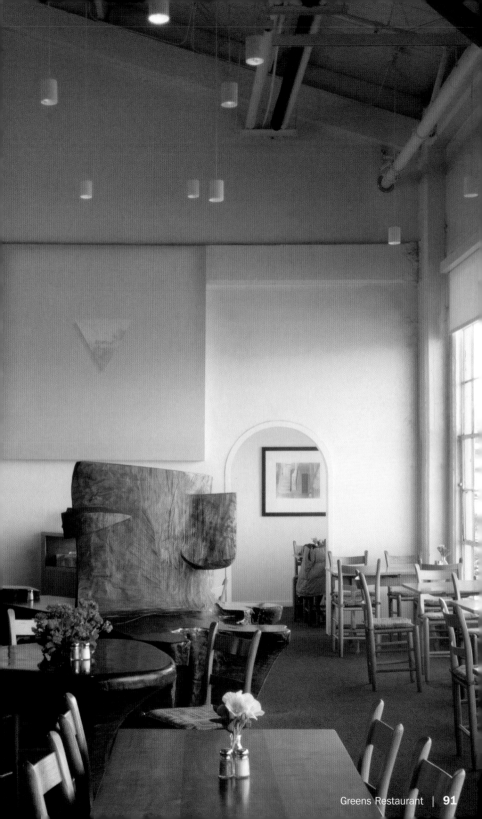

La Folie

Design: Walid Mando | Chef: Roland Passot
Owners: Roland & Jamie Passot

2316 Polk Street | San Francisco, CA 94109 | Russian Hill
Phone: +1 415 776 5577
www.lafolie.com
Opening hours: Mon-Sat 5:30 pm to 10:30 pm, Sun closed
Average price: $ 35
Cuisine: Modern French with Californian influence
Special features: Fine wine selection, private dining

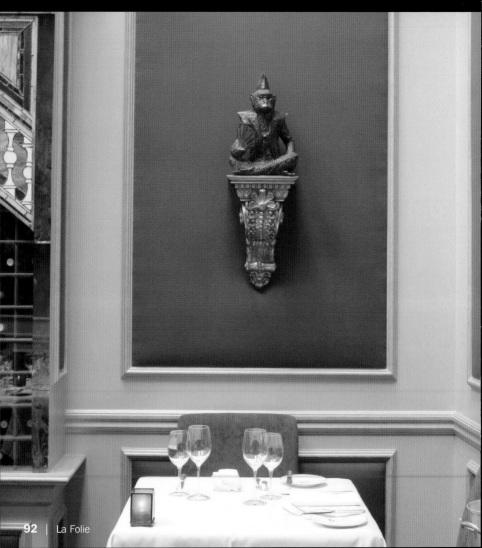

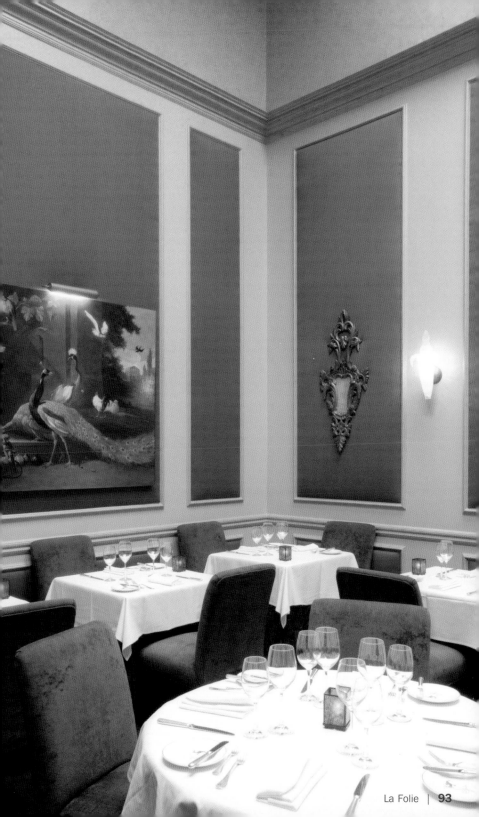

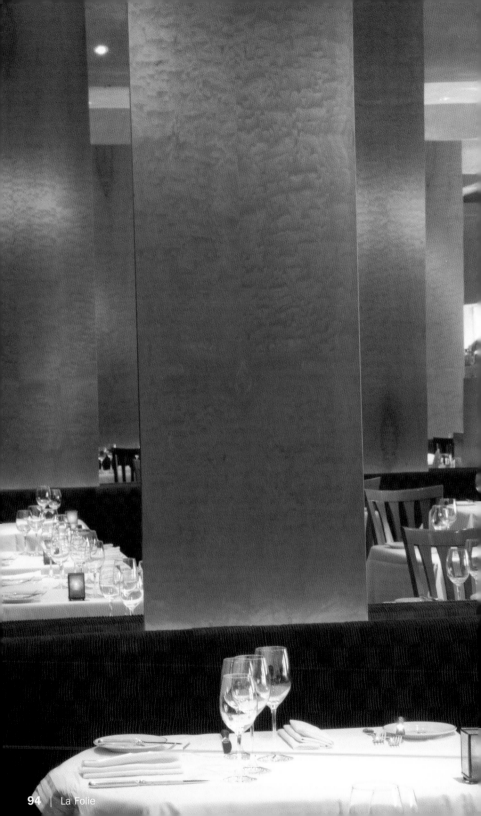

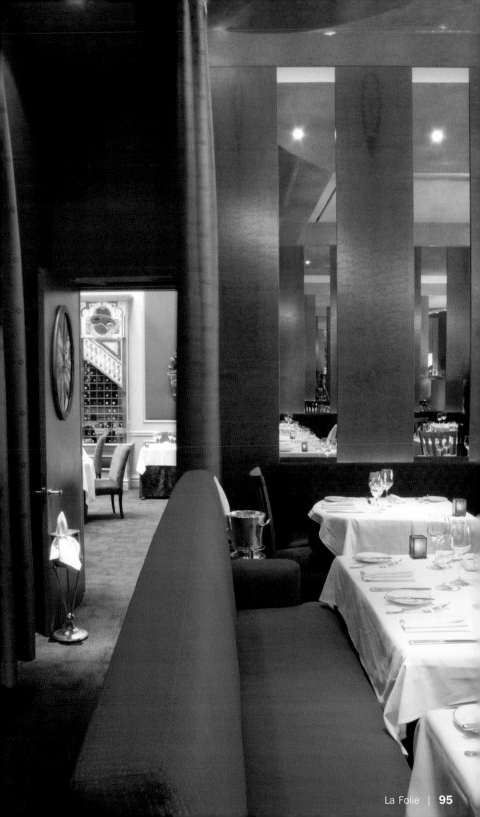

La Suite

Design: Dan, shopworks, www.shopworksdesign.com
Chef: Bruno Chemel | Owner: Jocelyn Bulow and partners

100 Brannan Street | San Francisco, CA 94107 | South Beach
Phone: +1 415 593 5900
www.lasuitesf.com
Opening hours: Lunch Mon–Sat 11:30 am to 3 pm, dinner Sun–Thu 5:30 pm to 11 pm,
Fri–Sat 5:30 pm to midnight
Average price: $ 24
Cuisine: French
Special features: Weekend brunch 10:30 am to 3 pm, outdoor/patio dining

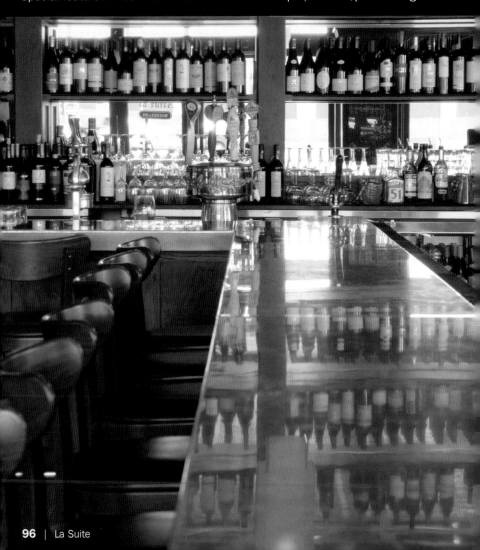

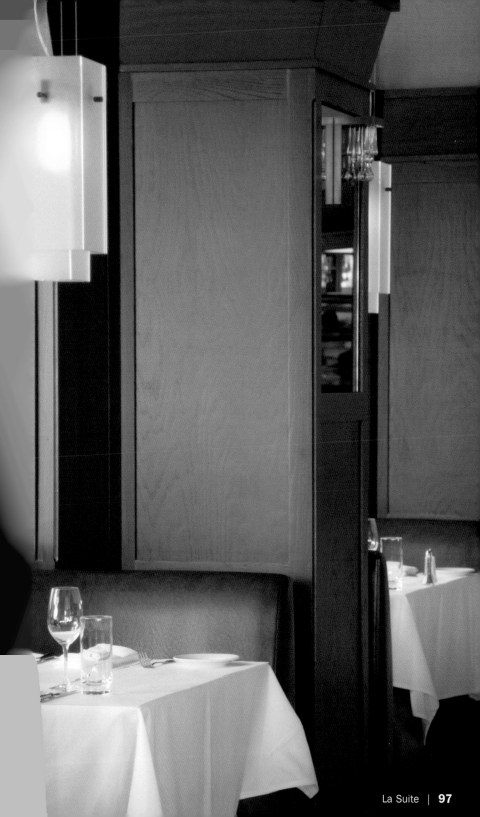

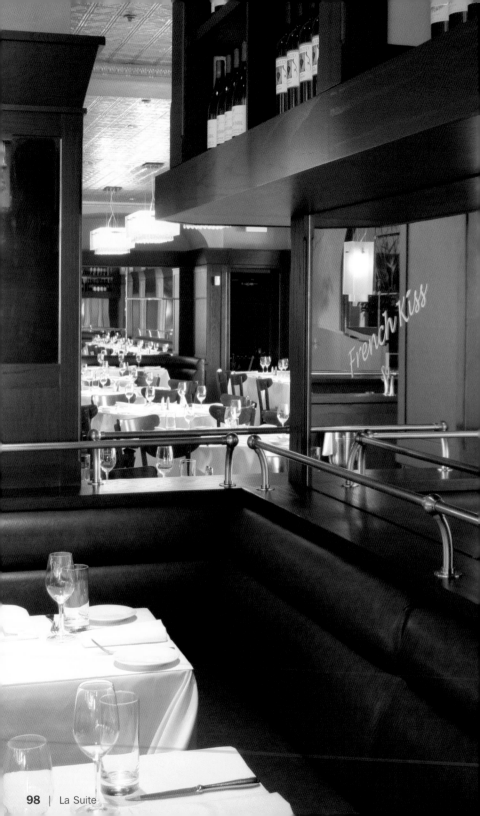

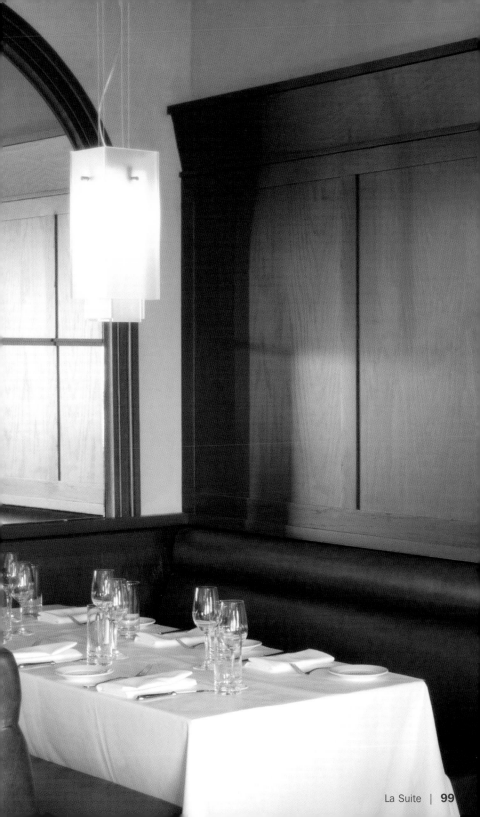

Limón

Design: Noise 13, www.noise13.com | Chef: Martin Castillo
Owner: Martin Castillo

524 Valencia Street | San Francisco, CA 94110 | Mission
Phone: +1 415 252 0918
www.limon-sf.com
Opening hours: Lunch Mon–Fri 11:30 am to 3 pm, dinner Mon–Thu 5 pm to
10:30 pm, Fri 5 pm to 11 pm, Sat noon to 11 pm, Sun noon to 10 pm
Menu price: $ 55
Cuisine: Traditional Peruvian, Nuevo Latino fusion
Special features: Limón also distributes foods directly from Peru, waiting lounge

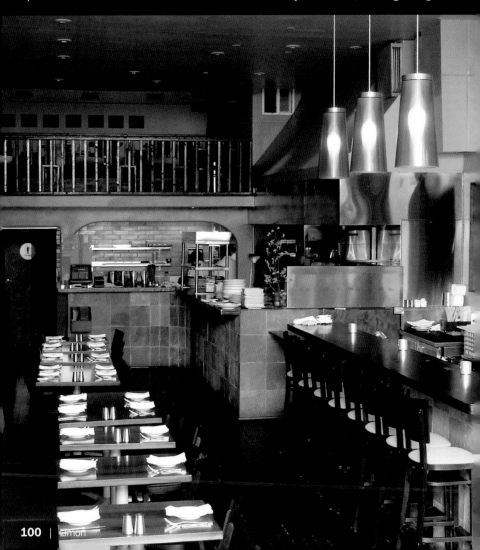

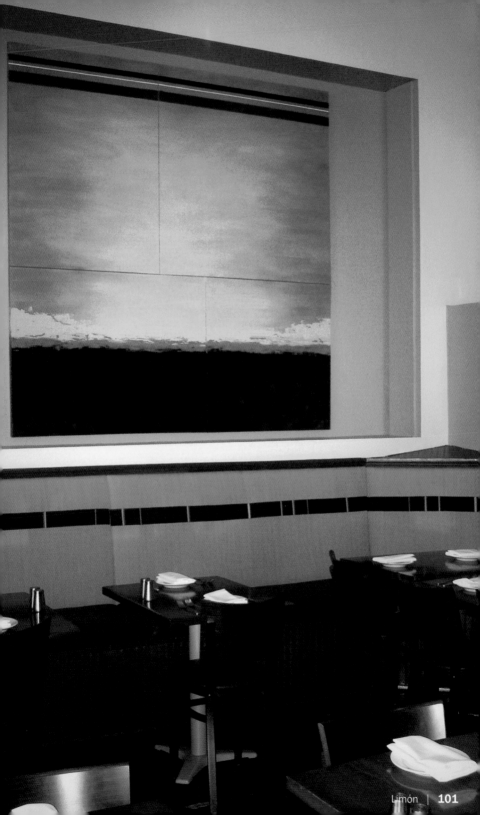

MECCA

Design: Stephen Brady | Chefs: Stephen Barber, Sergio Santiago
Owner: Gene Tartaglia

2029 Market Street | San Francisco, CA 94114 | Upper Market
Phone: +1 415 621 7000
www.sfmecca.com
Opening hours: Tue–Thu 5:30 pm to 10 pm, Fri–Sat 5:30 pm to 11 pm,
Sun 5 pm to 9:30 pm, Mon closed
Average price: $ 28
Cuisine: American
Special features: Urban DJ selection by music director Noel, bar

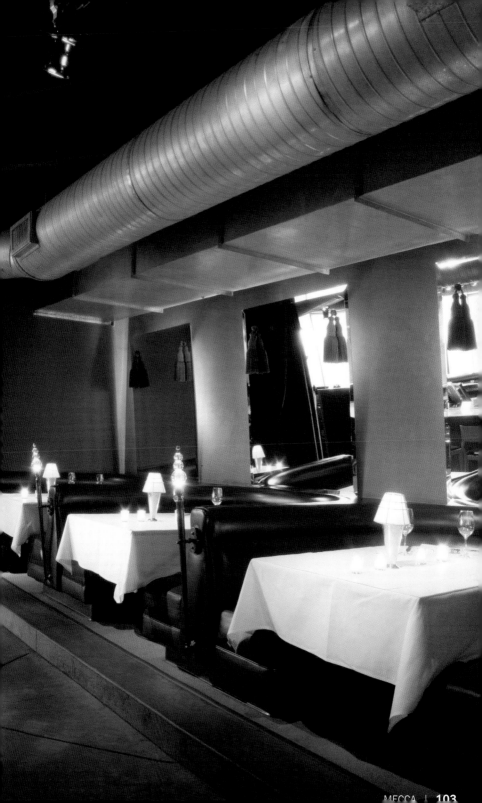

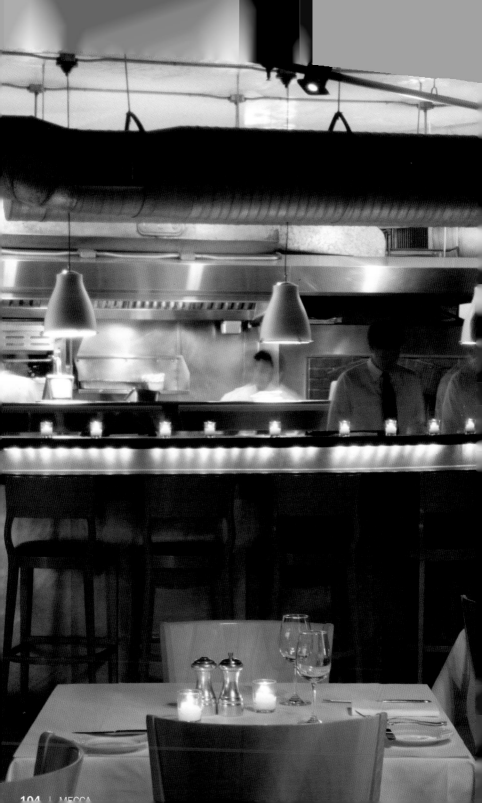

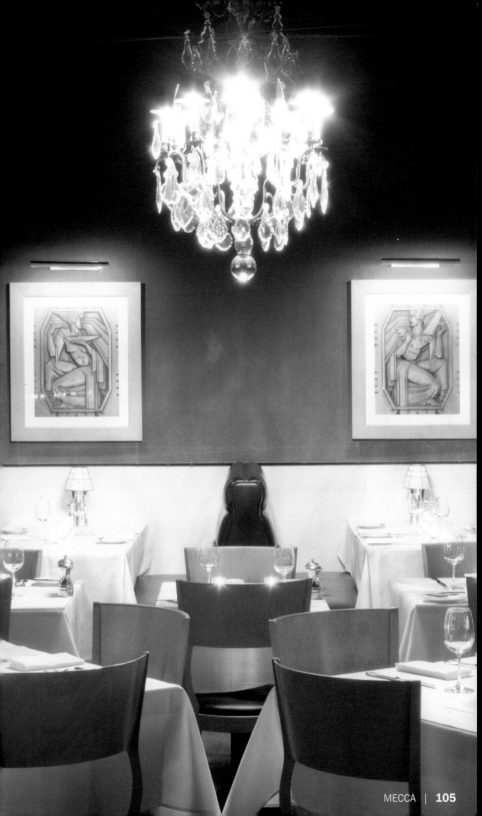

Molasses-Grilled
Duck Breast

Gegrillte Entenbrust in Melassenmarinade

Magrets de canard grillés et marinés à la mélasse

Pechuga de pato a la parrilla en marinada de melaza

Petto di anatra alla griglia in marinata di melassa

4 duck breasts
4 oz dark molasses
2 oz apple cider vinegar
2 tbsp lemon juice
2 oz mustard
4 oz tomato sauce
2 cloves of garlic, crushed
1 tsp habanero chili, chopped
1 tsp fresh ginger, chopped
1 tsp orange zest
1 tsp ground allspice
1 tsp fresh thyme, chopped
Pepper

Combine all marinade ingredients in a blender and mix until smooth. Reserve 4 tbsp of the marinade for decoration. Place the duck breasts in the marinade and refrigerate for at least 4 hours.
Remove duck breasts from marinade and grill on the fatty side for approx. 8 minutes. Turn over and repeat. Let breasts rest for 3 minutes, then cut each breast into thin slices, drizzle with the reserved marinade and serve with brown rice and vegetables.

4 Entenbrüste
120 ml dunkle Melasse
60 ml Apfelweinessig
2 EL Zitronensaft
60 g Senf
120 g Tomatensauce
2 Knoblauchzehen, gehackt
1 TL Habanero-Chili, gehackt
1 TL frischer Ingwer, gehackt
1 TL Orangenzeste
1 TL gemahlenes Piment
1 TL frischer Thymian, gehackt
Pfeffer

Alle Marinadenzutaten in einen Mixer geben und glatt mixen. 4 EL der Marinade zur Dekoration zurückbehalten. Die Entenbrüste in die Marinade geben und für mindestens 4 Stunden kaltstellen. Entenbrüste aus der Marinade nehmen und auf der Fettseite ca. 8 Minuten grillen. Wenden und wiederholen. Brüste für 3 Minuten ruhen lassen, dann jede Brust in dünne Scheiben schneiden, mit der zurückbehaltenen Marinade beträufeln und mit braunem Reis und Gemüse servieren.

4 magrets de canard
120 ml de mélasse brune
60 ml de vinaigre de cidre
2 c. à soupe jus de citron
60 g de moutarde
120 g de sauce tomate
2 gousses d'ail, hachées
1 c. à café de piment rouge habanero, haché
1 c. à café de gingembre frais, haché
1 c. à café de zeste d'orange
1 c. à café de piment moulu
1 c. à café de thym frais, haché
Poivre

Passer au mixer tous les ingrédients de la marinade et mixer jusqu'à l'obtention d'un mélange lisse. Conserver 4 c. à soupe de marinade pour la décoration. Faire mariner les magrets de canard et mettre au frais pendant au moins 4 heures. Retirer les magrets de canard de la marinade et les faire griller pendant environ 8 minutes du côté gras. Retourner et répéter le processus. Laisser reposer les filets pendant 3 minutes, puis couper chaque magret en tranches fines, arroser avec la marinade mise de côté et servir avec du riz brun et des légumes.

4 pechugas de pato
120 ml de melaza oscura
60 ml de vinagre de manzana
2 cucharadas de zumo de limón
60 g de mostaza
120 g de salsa de tomate
2 dientes de ajo, picados
1 cucharadita de chile habanero, picado
1 cucharadita de jengibre fresco, picado
1 cucharadita de piel de naranja, en tiras
1 cucharadita de pimentón, molido
1 cucharadita de tomillo fresco, picado
Pimienta

Ponga todos los ingredientes de la marinada en un robot de cocina y bata hasta obtener una mezcla homogénea. Reserve 4 cucharadas de la marinada para decorar. Introduzca las pechugas en la marinada y déjelas reposar en el frigorífico durante 4 horas como mínimo. Saque después la carne de la marinada y ásela por el lado de la grasa durante 8 minutos en la parrilla. Déles la vuelta a las pechugas y áselas otros 8 minutos más. Deje reposar la carne durante 3 minutos y córtela después en finas lonchas. Vierta por encima la marinada y sirva con arroz moreno y verdura.

4 petti di anatra
120 ml di melassa scura
60 ml di aceto di mele
2 cucchiai di succo di limone
60 g di senape
120 g di salsa di pomodoro
2 spicchi d'aglio tritati
1 cucchiaino di peperoncino habanero tritato
1 cucchiaino di zenzero fresco tritato
1 cucchiaino di scorza d'arancia
1 cucchiaino di pimento macinato
1 cucchiaino di timo fresco tritato
Pepe

Mettete tutti gli ingredienti per la marinata in un frullatore e frullate bene. Tenete da parte 4 cucchiai di marinata per decorare. Mettete i petti di anatra nella marinata e lasciateli raffreddare per almeno 4 ore. Togliete i petti di anatra dalla marinata e grigliateli dalla parte di grasso per ca. 8 minuti. Girate e ripetete. Lasciate riposare i petti per 3 minuti, dopo di che tagliate ogni petto a fette sottili, versatevi alcune gocce di marinata tenuta da parte e servite con riso integrale e verdura.

Slanted Door

Design: Lundberg Design, www.lundbergdesign.com
Chef: Charles Phan | Owners: The Phan Family

1 Ferry Building #3 | San Francisco, CA 94111 | Embarcadero
Phone: +1 415 861 8032
www.slanteddoor.com
Opening hours: Daily lunch 11 am to 2:30 pm, dinner Sun–Thu 5:30 pm to 10 pm,
Fri–Sat 5:30 pm to 10:30 pm
Average price: $ 23
Cuisine: Modern Vietnamese home cooking
Special features: European wine list, cocktail lounge, private dining room

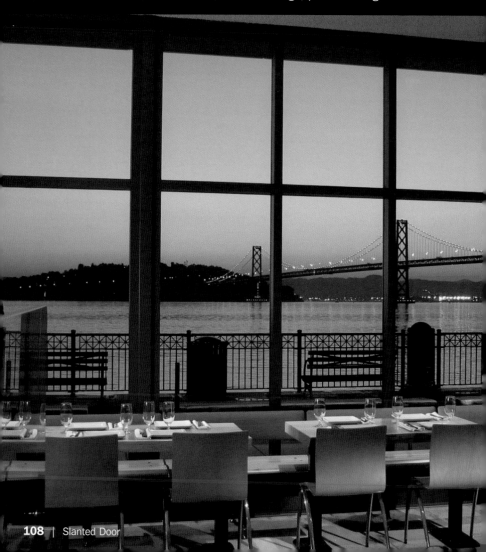

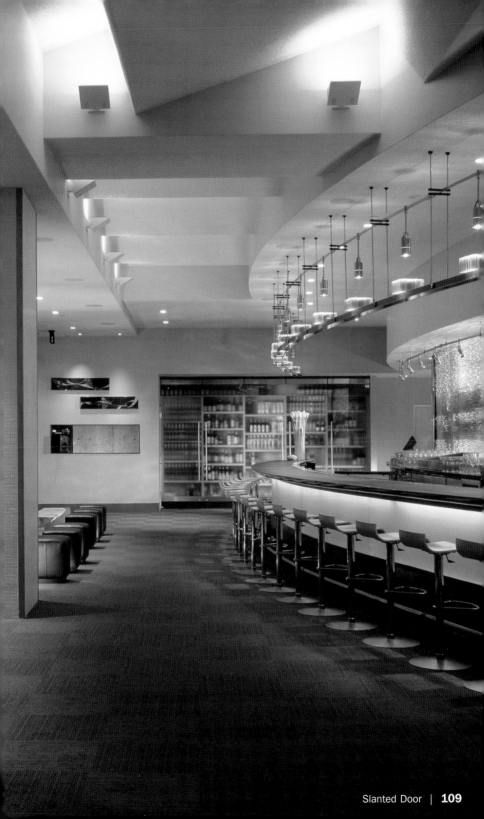

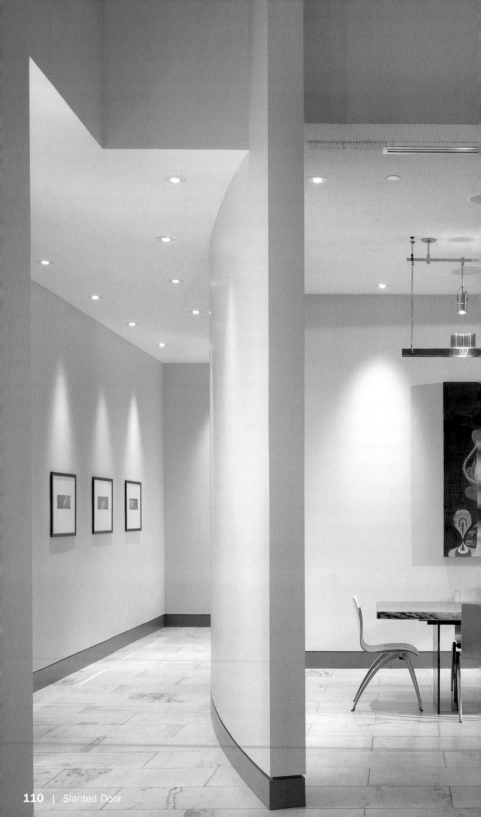

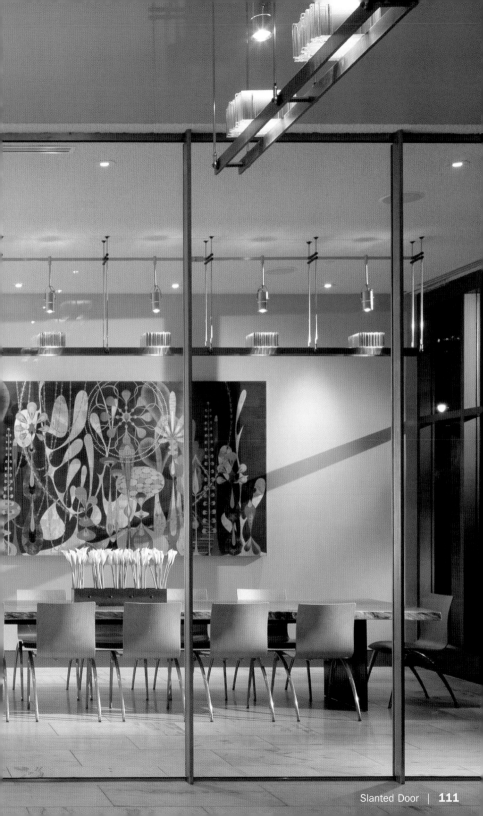

Grapefruit and Jicama Salad

Grapefruit- und Jicama-Salat
Salade de pamplemousses et de jicama
Ensalada de pomelo y jícama
Insalata di pompelmo e di jicama

3 tbsp soya sauce
1 tbsp rice wine vinegar
1 tbsp sugar
1 tsp garlic, chopped
1 small chili, chopped
2 tsp vegetable oil
Salt and pepper

10 oz red cabbage, shredded
4 oz jicama (Mexican turnip), grated
4 oz carrots, grated
2 tbsp mint leaves, chopped
3 tbsp pecans, chopped
2 grapefruits, segmented

Mix soya sauce, vinegar, sugar, garlic, chili and oil in a small bowl. Season with salt and pepper. Combine cabbage, jicama, carrots, mint leaves, pecans and grapefruits in a large bowl, add vinaigrette and toss carefully. Marinade for at least 30 minutes.

3 EL Sojasauce
1 EL Reisweinessig
1 EL Zucker
1 TL Knoblauch, gehackt
1 kleine Chilischote, gehackt
2 TL Pflanzenöl
Salz, Pfeffer

300 g roter Kohl, geraspelt
120 g Jicama (Mexikanische Rübe), geraspelt
120 g Möhren, geraspelt
2 EL Minzblätter, gehackt
3 EL Pekannüsse, gehackt
2 Grapefruits, filetiert

Sojasauce, Essig, Zucker, Knoblauch, Chilischote und Öl in einer kleinen Schüssel mischen. Mit Salz und Pfeffer würzen. Kohl, Jicama, Möhren, Minzblätter, Pekannüsse und Grapefruits in einer großen Schüssel mischen, die Vinaigrette dazugeben und vorsichtig unterheben. Für mindestens 30 Minuten marinieren.

3 c. à soupe de sauce soja
1 c. à soupe vinaigre de riz
1 c. à soupe de sucre
1 c. à café d'ail, haché
1 petit piment rouge, haché
2 c. à café d'huile végétale
Sel, poivre

300 g de chou rouge, râpé
120 g de jicama (navet du Mexique), râpé
120 g de carottes, râpées
2 c. à soupe de feuilles de menthe, hachées
3 c. à soupe de noix de Pécan, hachées
2 pamplemousses, en quartiers

Mélanger dans un petit saladier la sauce soja, le vinaigre, le sucre, l'ail, le piment rouge et l'huile. Saler et poivrer. Mélanger dans un grand saladier le chou, le jicama, les carottes, les feuilles de menthe, les noix de Pécan et les pamplemousses, ajouter la vinaigrette et l'incorporer précautionneusement. Laisser mariner pendant au moins 30 minutes.

3 cucharadas de salsa de soja
1 cucharada de vinagre de vino de arroz
1 cucharada de azúcar
1 cucharadita de ajo, picado
1 guindilla pequeña, picada
2 cucharaditas de aceite vegetal
Sal, pimienta

300 g de lombarda, rallada
120 g de jícama (tubérculo mexicano), rallada
120 g de zanahorias, ralladas
2 cucharadas de hojas de menta, picadas
3 cucharadas de pacanas, picadas
2 pomelos, fileteados

Mezcle en un cuenco pequeño la salsa de soja, el vinagre, el azúcar, el ajo, la guindilla y el aceite. Salpimiente. En un cuenco grande mezcle la lombarda, la jícama, la menta, las pacanas y los pomelos, añada la vinagreta y remueva con cuidado. Deje marinar los ingredientes durante 30 minutos como mínimo.

3 cucchiai di salsa di soia
1 cucchiaio di aceto di riso
1 cucchiaio di zucchero
1 cucchiaino di aglio tritato
1 peperoncino piccolo tritato
2 cucchiaini di olio vegetale
Sale, pepe

300 g di cavolo rosso, grattugiato
120 g di jicama (rapa messicana) grattugiata
120 g di carote grattugiate
2 cucchiai di foglie di menta tritate
3 cucchiai di noci pecan tritate
2 pompelmi tagliati a filetti

In una ciotola piccola mescolate la salsa di soia, l'aceto, lo zucchero, l'aglio, il peperoncino e l'olio. Salate e pepate. In una ciotola grande mescolate il cavolo, la jicama, le carote, le foglie di menta, le noci pecan e i pompelmi, aggiungete la vinagrette e mescolate bene e con cura. Fate marinare per almeno 30 minuti.

Slow Club

Design: Praxis | Chef: Sante Salvoni | Owner: Erin Rooney

2501 Mariposa Street | San Francisco, CA 94110 | Mission
Phone: +1 415 241 9390
www.slowclub.com
Opening hours: Lunch Mon–Fri 11:30 am to 2:30 pm, brunch Sat–Sun 10 am to
2:30 pm, dinner Mon–Thu 6:30 pm to 10 pm, Fri 6:30 pm to 11 pm, Sat 6 pm to
11 pm, pastry & coffee Mon–Fri 7 am to 11 am
Average price: $ 16
Cuisine: Contemporary American

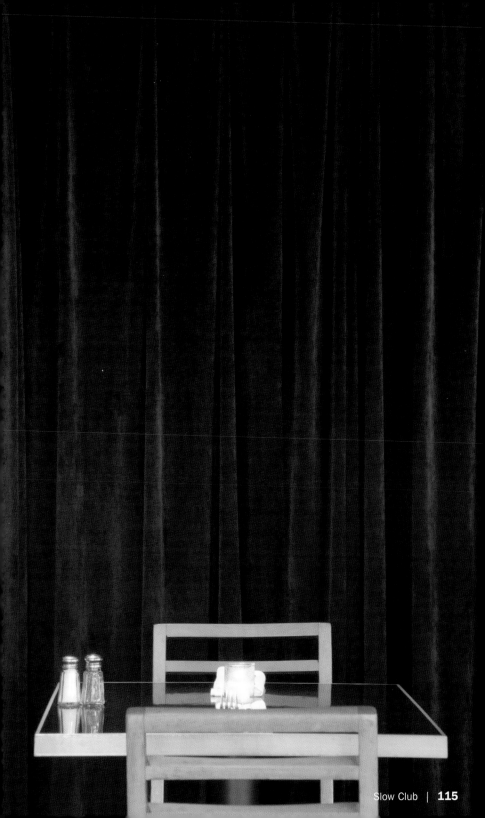

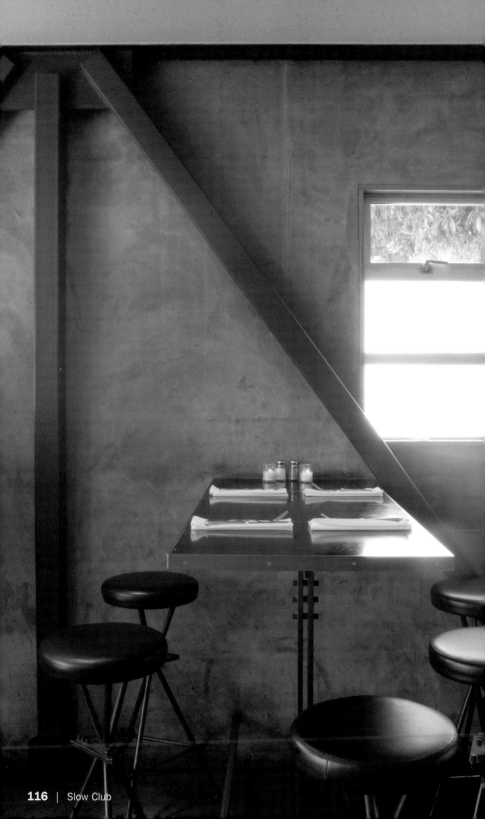

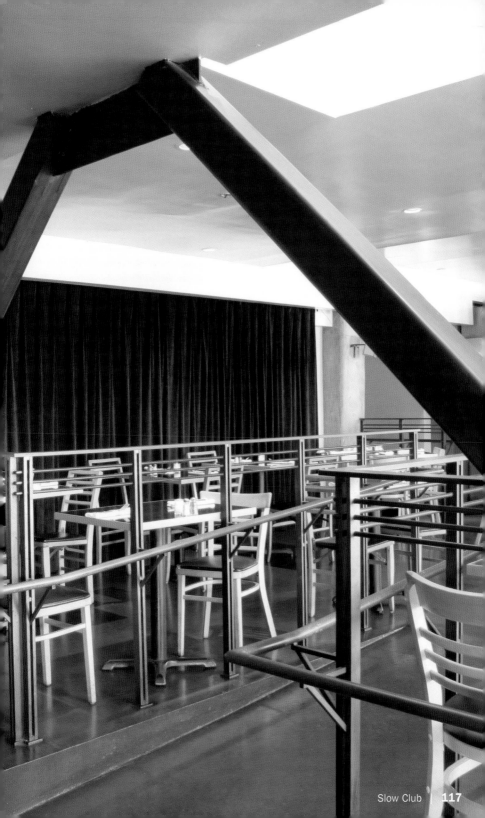

Tartare

Design: Michael Brennan | Chef: George Morrone | Sommelier:
Paul Einbund | Owners: George Morrone, Aabi Shapoorian

550 Washington Street | San Francisco, CA 94111 | Financial District
Phone: +1 415 434 3100
www.tartarerestaurant.com, www.michaelbrennandesign.com
Opening hours: Lunch Tue–Fri 11:30 am to 2 pm, dinner Mon–Thu 5:30 pm to
10 pm, Fri–Sat 5:30 to 11 pm
Menu price: $ 55
Cuisine: Modern French
Special features: Exclusive wine list co-created by a trio of sommeliers

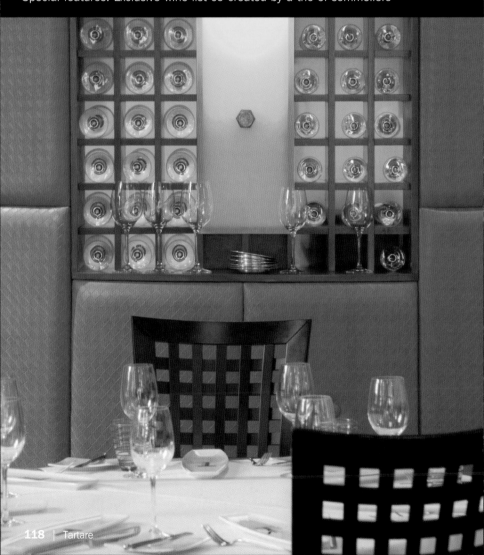

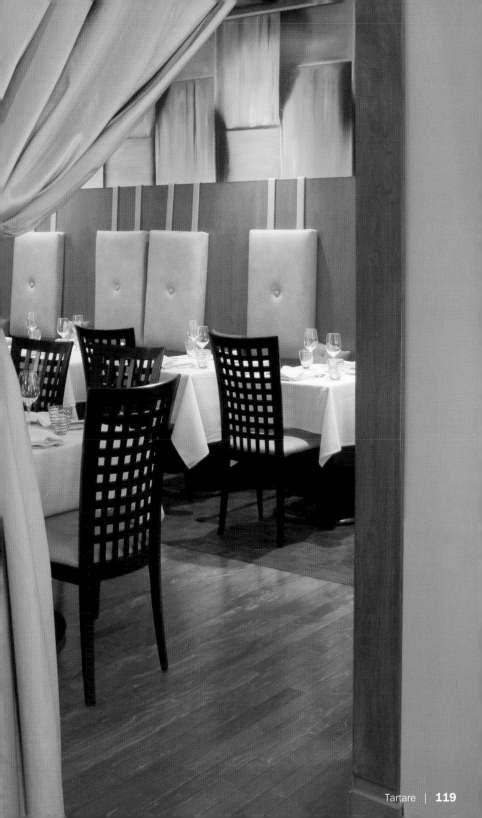

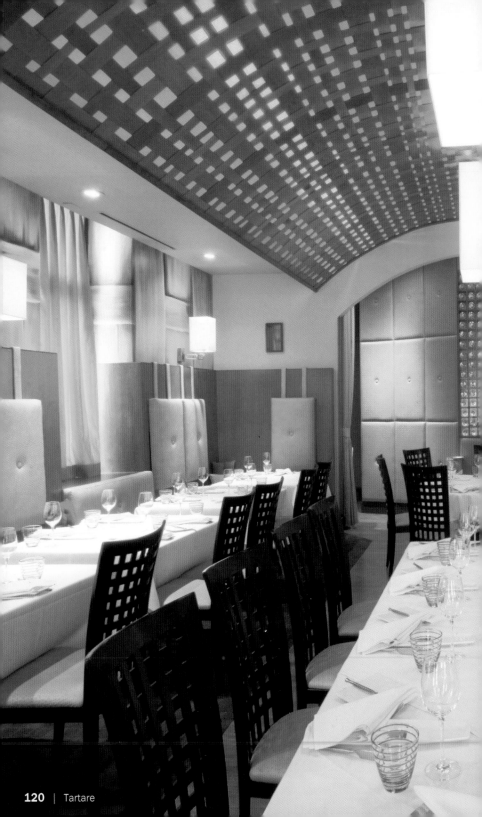

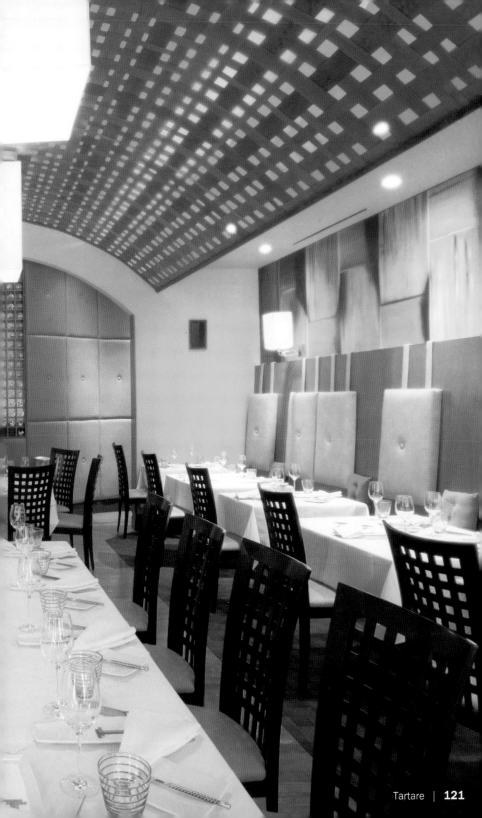

Pineapple Brown Butter Tart

Ananas-Braune-Butter-Tart

Tarte à l'ananas et au beurre noisette

Tarta de piña con mantequilla dorada

Tortino di ananas e burro nocciola

6 oz butter
1/2 vanilla bean
3 eggs
6 oz brown sugar
3 oz corn syrup
1 pinch of salt
2 oz flour
4 slices fresh pineapple

Melt butter over medium heat until light brown. Remove from the heat and add the vanilla bean. Whisk together the eggs, brown sugar, corn syrup and salt. Add flour and brown butter to the egg mixture. Remove vanilla bean. Pour into four small, greased, circular baking dishes and top with a slice of pineapple. Bake at 350 °F for about 15 minutes. Serve with vanilla ice-cream and pineapple chutney.

180 g Butter
1/2 Vanilleschote
3 Eier
180 g brauner Zucker
90 ml Maissirup
1 Prise Salz
60 g Mehl
4 Scheiben frische Ananas

Butter bei mittlerer Hitze leicht bräunen lassen. Von der Flamme nehmen und die Vanilleschote zugeben. Eier, braunen Zucker, Maissirup und Salz miteinander aufschlagen. Mehl und braune Butter zur Eiermischung geben. Vanilleschote herausnehmen. In vier kleine, gefettete, runde Backformen geben und mit einer Scheibe Ananas belegen. Bei 180 °C ca. 15 Minuten backen. Mit Vanilleeiscreme und Ananas-Chutney servieren.

180 g de beurre
1/2 gousse de vanille
3 œufs
180 g de sucre brun
90 ml de sirop de maïs
1 pincée de sel
60 g de farine
4 tranches d'ananas frais

Faire brunir le beurre à feu moyen. Retirer du feu et ajouter la gousse de vanille. Battre les œufs, le sucre brun, le sirop de maïs et le sel. Ajouter la farine et le beurre noisette au mélange à base d'œufs. Retirer la gousse de vanille. Mettre dans quatre petits moules ronds beurrés et recouvrir d'une tranche d'ananas. Cuire pendant environ 15 minutes à 180 °C. Servir avec de la glace à la vanille et du chutney à l'ananas.

180 g de mantequilla
1/2 de rama de vainilla
3 huevos
180 g de azúcar moreno
90 ml de sirope de maíz
1 pizca de sal
60 g de harina
4 rodajas de piña fresca

Dore la mantequilla a fuego medio. Retire la cazuela del fuego y añada la vainilla. Bata los huevos con el azúcar moreno, el sirope de maíz y la sal. Incorpore la harina y la mantequilla dorada. Extraiga la vainilla. Reparta la mezcla en cuatro moldes para hornear engrasados y redondos y ponga encima una rodaja de piña. Hornee durante 15 minutos a 180 °C. Sirva con crema de helado de vainilla y chutney de piña.

180 g di burro
1/2 stecca di vaniglia
3 uova
180 g di zucchero di canna
90 ml di sciroppo di mais
1 pizzico di sale
60 g di farina
4 fette di ananas fresco

Fate dorare leggermente il burro a fuoco medio. Togliete dalla fiamma e aggiungete la stecca di vaniglia. Montate insieme uova, zucchero di canna, sciroppo di mais e sale. Unite al composto di uova la farina e il burro nocciola. Togliete la stecca di vaniglia. Mettete in quattro stampini per dolci rotondi e unti e ricoprite ogni stampino con una fetta di ananas. Cuocete in forno a 180 °C per ca. 15 minuti. Servite con gelato alla vaniglia e chutney di ananas.

Town Hall

Design: Mark Zeff, www.zeffdesign.com | Chefs & Owners:
Mitchell & Steven Rosenthal | Co-Owner: Doug Washington

342 Howard Street | San Francisco, CA 94105 | Rincon Hill
Phone: +1 415 908 3900
www.townhallsf.com
Opening hours: Lunch Mon–Fri 11:30 am to 2:30 pm, dinner Sun–Thu 5:30 pm
to 10 pm, Fri–Sat 5:30 pm to 11 pm
Average price: $ 27
Cuisine: American traditional
Special features: Patio/outdoor dining

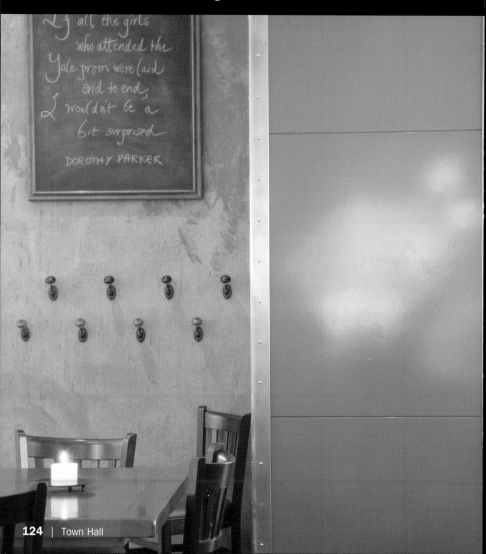

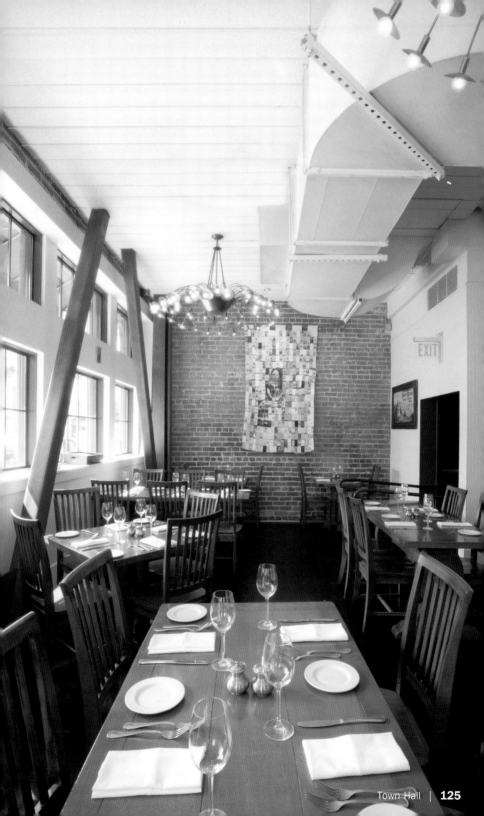

Butterscotch Pot de Crème

Butterscotch Pot de Crème
Pots de crème au butterscotch
Pot de creme con butterscotch
Pot de Creme al butterscotch

20 oz cream
1 vanilla bean
1 pinch of salt
5 oz butterscotch chips
5 egg yolks
2 tbsp brown sugar
1 tbsp water
1 tbsp cream
1 tbsp Scotch Whisky

In a medium pot, combine cream, vanilla bean and salt. Bring to a boil and remove from the stove. Add butterscotch chips and whisk until smooth. In a separate bowl, whisk egg yolks, add a little of the butterscotch-mixture, then pour the egg yolks back into the pot. Set aside. Combine brown sugar, water, cream and Scotch Whisky in a small saucepan, bring to a boil and add to the butterscotch-mixture.
Pour mixture into a metal pan and place the pan into a larger metal pan (to use a water bath). Place both pans in pre-heated 275 °F oven and cover the butterscotch-mixture with aluminum foil. Pour very hot water into second pan, halfway up the sides. Bake for 1 hour. Strain immediately and allow to cool for 10 minutes. Whisk until smooth and then pour into four desert dishes. Chill. Top with Buttercrunch Candy.

600 ml Sahne
1 Vanilleschote
1 Prise Salz
150 g Butterscotch Chips
5 Eigelbe
2 EL brauner Zucker
1 EL Wasser
1 EL Sahne
1 EL Scotch Whisky

Sahne, Vanilleschote und Salz in einen mittleren Topf geben. Aufkochen lassen und vom Herd nehmen. Butterscotch Chips zufügen und glatt rühren. Eigelbe in einer separaten Schüssel aufschlagen, etwas von der Butterscotch-Mischung hineingeben und zurück in den Topf gießen. Beiseite stellen. Brauner Zucker, Wasser, Sahne und Scotch Whisky in einen kleinen Topf geben, aufkochen lassen und in die Butterscotch-Mischung geben.
Die Mischung in eine Metallform schütten und diese Form in eine größere Metallform stellen (als Wasserbad benutzen). Beide Formen in einen auf 135 °C vorgeheizten Ofen geben und die Butterscotch-Mischung mit Alufolie abdecken. Die zweite Form zur Hälfte mit sehr heißem Wasser füllen. 1 Stunde lang backen. Sofort das Wasser abgießen und 10 Minuten abkühlen lassen. Glatt rühren und in vier Dessertschälchen gießen. Kaltstellen. Mit Buttercrunch-Keksen dekorieren.

600 ml de crème
1 gousse de vanille
1 pincée de sel
150 g de chips au butterscotch
5 jaunes d'œuf
2 c. à soupe de sucre brun
1 c. à soupe d'eau
1 c. à soupe de crème
1 c. à soupe de Scotch Whisky

Mettre dans une casserole de taille moyenne la crème, la gousse de vanille et le sel. Amener à ébullition et retirer du feu. Ajouter les chips au butterscotch et mélanger pour obtenir une consistance lisse. Battre les jaunes d'œuf dans un saladier séparé, ajouter un peu du mélange à base de butterscotch et reverser dans la casse-role. Mettre de côté. Verser dans une casserole le sucre brun, l'eau, la crème et le Scotch Whisky laisser mijoter et ajouter au mélange à base de butterscotch.

Verser le mélange dans un moule en métal et placer ce moule dans un moule en métal plus grand (utiliser comme bain-marie). Mettre les deux moules dans le four préchauffé à 135 °C et recouvrir d'une feuille d'aluminium le mélange à base de butterscotch. Remplir à moitié le second moule d'eau très chaude. Cuire pendant 1 heure. Vider l'eau immédiatement et laisser refroidir pendant 10 minutes. Mélanger pour obtenir une consistance lisse et verser dans quatre coupes à dessert. Mettre au frais. Décorer de biscuits croustillants au beurre.

600 ml de nata
1 rama de vainilla
1 pizca de sal
150 g de copos de butterscotch (caramelo de azúcar y mantequilla)
5 yemas
2 cucharadas de azúcar moreno
1 cucharada de agua
1 cucharada de nata
1 cucharada de whisky escocés

Ponga la nata, la vainilla y la sal en una cazuela mediana. Lleve la mezcla a ebullición y retire después la cazuela del fuego. Añada los copos de butterscotch y remueva hasta conseguir una pasta uniforme. Bata las yemas en un cuenco y añada un poco del caramelo. Vierta la pasta en la cazuela y reserve. Ponga el azúcar moreno, el agua, la nata y el whisky escocés en un cazo pequeño, lleve a ebullición y vierta la mezcla en el caramelo.

Ponga la mezcla en un molde metálico e intro-dúzcalo en un molde más grande (para el baño maría). Precaliente el horno a 135 °C, cubra la mezcla del caramelo con papel de aluminio y meta los moldes en el horno. Llene el segundo molde hasta la mitad con agua muy caliente y hornee durante 1 hora. Elimine inmediatamente después el agua y deje que los moldes se enfríen durante 10 minutos. Remueva la mezcla y repár-tala en cuatro cuencos de postre. Póngalos a enfriar. Decore con galletas de mantequilla.

600 ml di panna
1 stecca di vaniglia
1 pizzico di sale
150 g di pezzetti di butterscotch (una specie di caramello duro)
5 tuorli d'uovo
2 cucchiai di zucchero di canna
1 cucchiaio di acqua
1 cucchiaio di panna
1 cucchiaio di scotch whisky

In una pentola di media grandezza mettete la panna, la stecca di vaniglia e il sale. Portate ad ebollizione e togliete dal fuoco. Aggiungete i pezzetti di butterscotch e mescolate bene. In una ciotola a parte sbattete i tuorli d'uovo, aggiunge-tevi un po' di composto di butterscotch e versate il tutto nella pentola. Mettete da parte. In un pentolino mettete lo zucchero di canna, l'acqua, la panna e lo scotch whisky, portate ad ebollizio-ne e incorporate al composto di butterscotch.

Versate il composto in uno stampo di metallo e mettete questo stampo in uno stampo di metallo più grande (che userete per un bagnomaria). Passate i due stampi in forno preriscaldato a 135 °C e coprite il composto di butterscotch con carta alluminio. Riempite il secondo stampo con acqua bollente fino a metà. Cuocete in forno per 1 ora. Versate subito via l'acqua e fate raffred-dare per 10 minuti. Mescolate bene e versate in quattro coppette da dessert. Mettete a raffredda-re. Decorate con biscottini croccanti al burro.

Zuni Café

Design: Guy Stiles | Chef: Judy Rodgers
Owners: Judy Rodgers, Vince Calcagno

1658 Market Street | San Francisco, CA 94102 | Hayes Valley
Phone: +1 415 552 2522
Opening hours: Tue–Sat 11:30 am to midnight, Sun 11 am to 11 pm
Average price: $ 45
Cuisine: Mediterranean influenced French & Italian
Special features: Sunday brunch, award winning cookbook, contemporary art

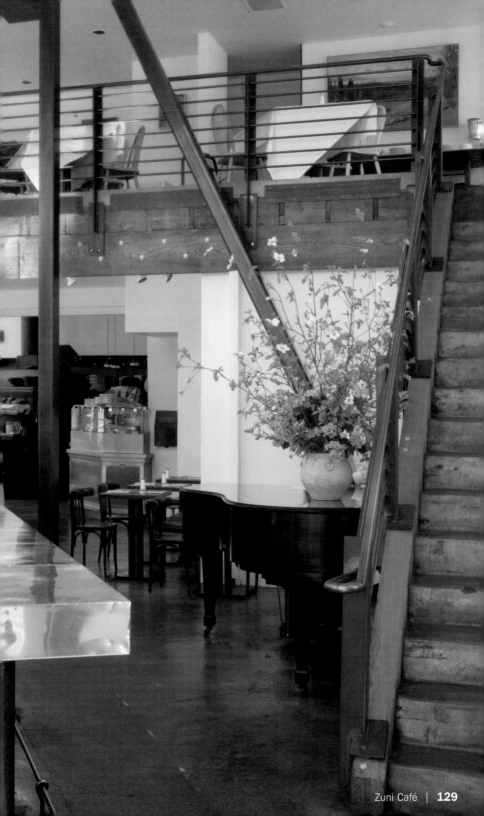

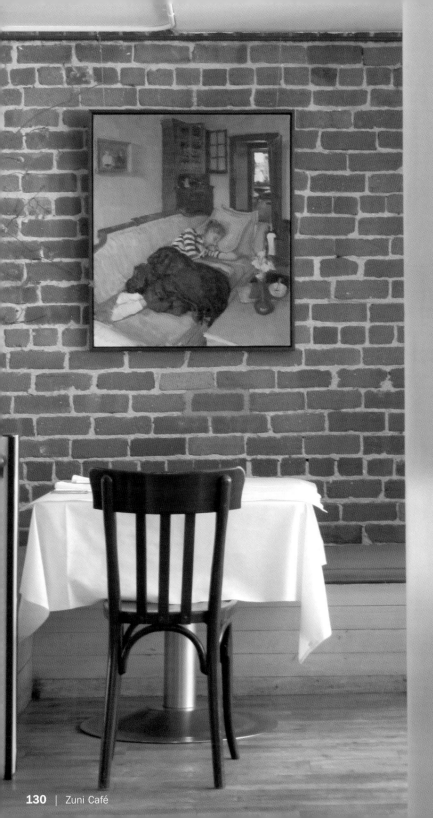

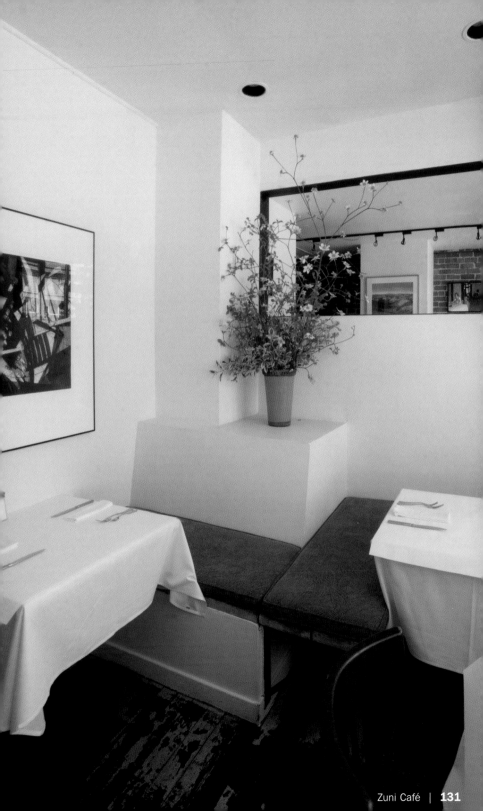

Raw White Asparagus Salad

Roher weißer Spargelsalat

Salade d'asperges blanches crues

Ensalada de espárragos blancos crudos

Insalata di asparagi bianchi crudi

4 raw white asparagus spears
2 tbsp lemon juice
2 tbsp olive oil
1 tbsp chervil, chopped
Salt and pepper
2 tbsp bottarga di tonno (tuna caviar)

Chill four plates. Mix all the liquid ingredients, herbs and seasonings in a small bowl. Chill. Wash and peel asparagus. Cut asparagus into very thin, long slices, using a vegetable peeler. Place asparagus slices on chilled plates, drizzle with vinaigrette and garnish with tuna caviar.

4 Stangen roher weißer Spargel
2 EL Zitronensaft
2 EL Olivenöl
1 EL Kerbel, gehackt
Salz, Pfeffer
2 EL Bottarga di Tonno (Thunfischkaviar)

Vier Teller kaltstellen. Alle flüssigen Zutaten, Kräuter und Gewürze in einer kleinen Schüssel mischen. Kaltstellen. Spargel waschen und schälen. Spargel mit einem Spargelschäler in sehr feine, lange Streifen schneiden. Spargelstreifen auf den gekühlten Tellern anrichten, mit der Vinaigrette beträufeln und mit dem Thunfischkaviar garnieren.

4 asperges blanches crues
2 c. à soupe de jus de citron
2 c. à soupe d'huile d'olive
1 c. à soupe de cerfeuil, haché
Sel, poivre
2 c. à soupe de Bottarga di Tonno
(caviar de thon)

Mettre au frais quatre assiettes. Mélanger tous les ingrédients liquides, les herbes et les épices dans un petit saladier. Mettre au frais. Laver et éplucher les asperges. A l'aide d'un épluche-asperge, couper les asperges en longues et fines lanières. Disposer celles-ci sur les assiettes fraîches, arroser de vinaigrette et garnir avec le caviar de thon.

4 espárragos blancos crudos
2 cucharadas de zumo de limón
2 cucharadas de aceite de oliva
1 cucharada de perifollo, picado
Sal, pimienta
2 cucharadas de bottarga di tonno
(caviar de atún)

Ponga cuatro platos a enfriar. En un cuenco pequeño mezcle todos los ingredientes líquidos junto con las hierbas y los condimentos. Con un pelador de espárragos corte los espárragos en tiras alargadas muy finas. Reparta las tiras en los platos, vierta por encima la vinagreta y adorne con el caviar.

4 asparagi bianchi interi crudi
2 cucchiai di succo di limone
2 cucchiai di olio d'oliva
1 cucchiaio di cerfoglio tritato
Sale, pepe
2 cucchiai di bottarga di tonno

Mettete a raffreddare quattro piatti. In una ciotola piccola mescolate insieme gli ingredienti liquidi, le erbe e le spezie. Mettete a raffreddare. Lavate e mondate gli asparagi. Tagliate gli asparagi a strisce lunghe e sottili con un pela asparagi. Mettete le strisce di asparagi sui piatti precedentemente raffreddati, versatevi alcune gocce di vinaigrette e guarnite con la bottarga di tonno.

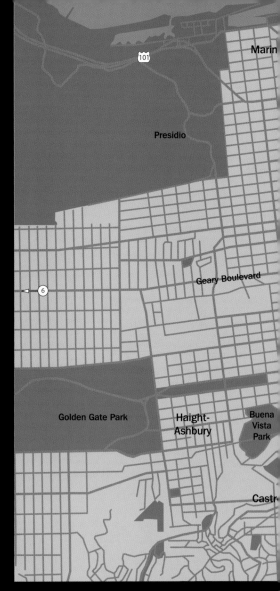

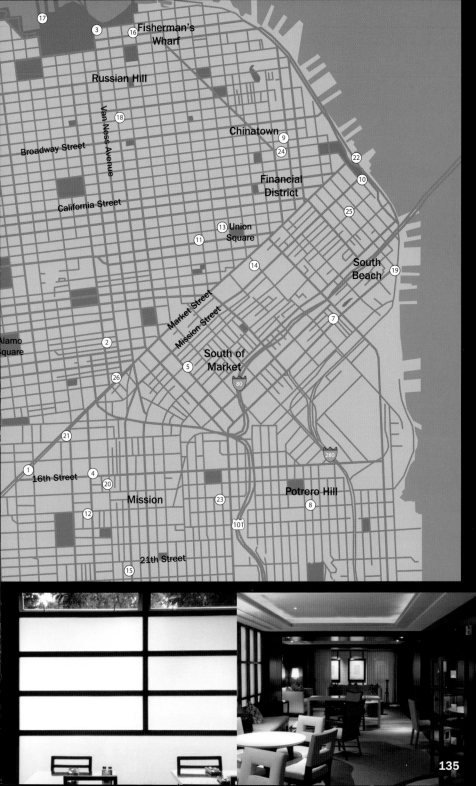

Cool Restaurants

Size: 14 x 21.5 cm / 5 ¹/₂ x 8 ¹/₂ in.
136 pp
Flexicover
c. 130 color photographs
Text in English, German, French,
Spanish and (*) Italian / (**) Dutch

Other titles in the same series:

Amsterdam (*)
ISBN 3-8238-4588-8

Barcelona (*)
ISBN 3-8238-4586-1

Berlin (*)
ISBN 3-8238-4585-3

Brussels (**)
ISBN 3-8327-9065-9

Chicago (*)
ISBN 3-8327-9018-7

Côte d'Azur (*)
ISBN 3-8327-9040-3

Hamburg (*)
ISBN 3-8238-4599-3

London
ISBN 3-8238-4568-3

Los Angeles (*)
ISBN 3-8238-4589-6

Madrid (*)
ISBN 3-8327-9029-2

Miami (*)
ISBN 3-8327-9066-7

Milan (*)
ISBN 3-8238-4587-X

Munich (*)
ISBN 3-8327-9019-5

New York
ISBN 3-8238-4571-3

Paris
ISBN 3-8238-4570-5

Prague (*)
ISBN 3-8327-9068-3

Rome (*)
ISBN 3-8327-9028-4

Shanghai (*)
ISBN 3-8327-9050-0

Sydney (*)
ISBN 3-8327-9027-6

Tokyo (*)
ISBN 3-8238-4590-X

Vienna (*)
ISBN 3-8327-9020-9

Zurich (*)
ISBN 3-8327-9069-1

To be published in the same series:

Cape Town
Copenhagen
Dubai
Geneva
Hong Kong
Ibiza/Majorca
Istanbul

Las Vegas
Mexico City
Moscow
Singapore
Stockholm
Toscana

teNeues